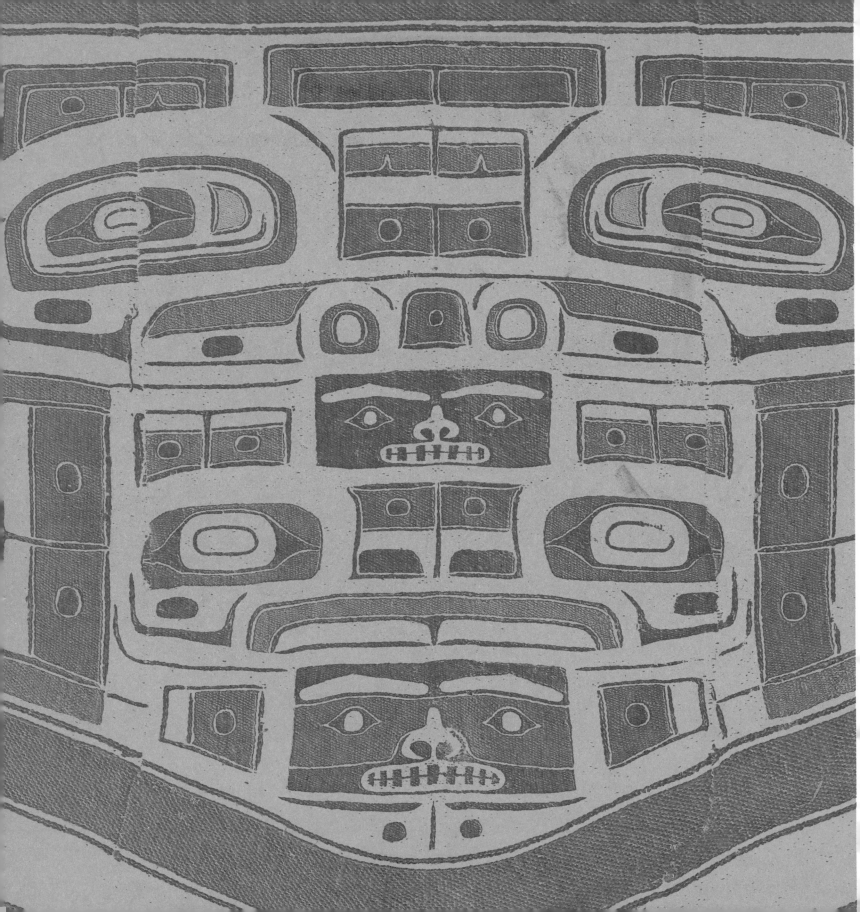

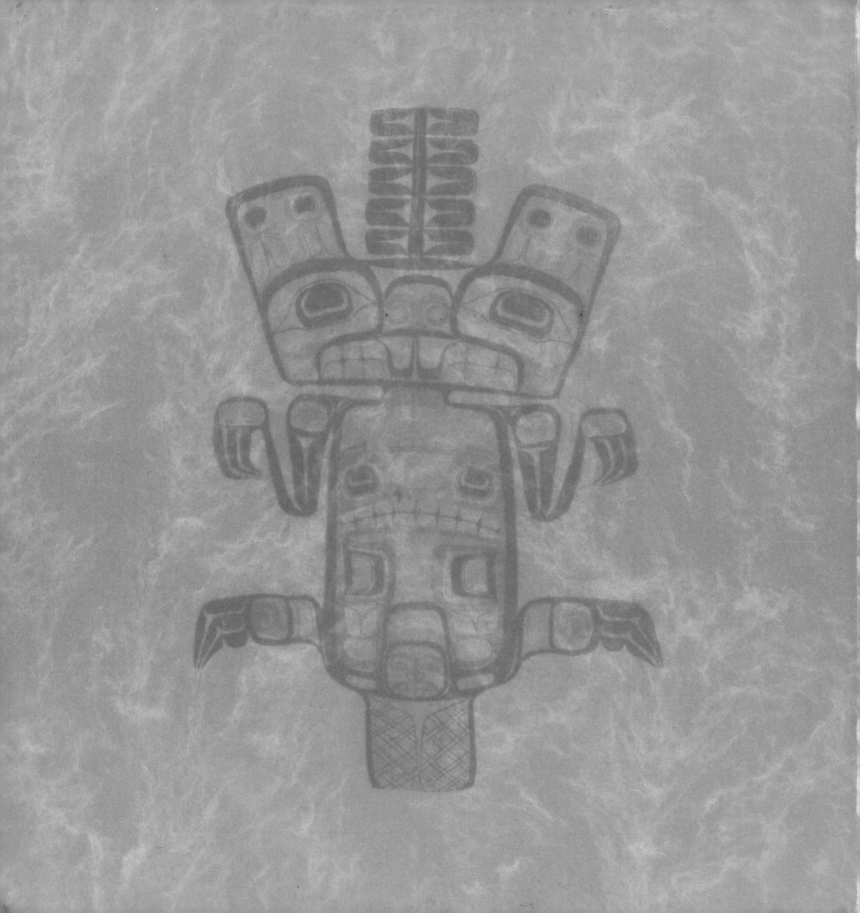

HAMLYN

THE ART OF **NATIVE NORTH AMERICA**

NIGEL CAWTHORNE

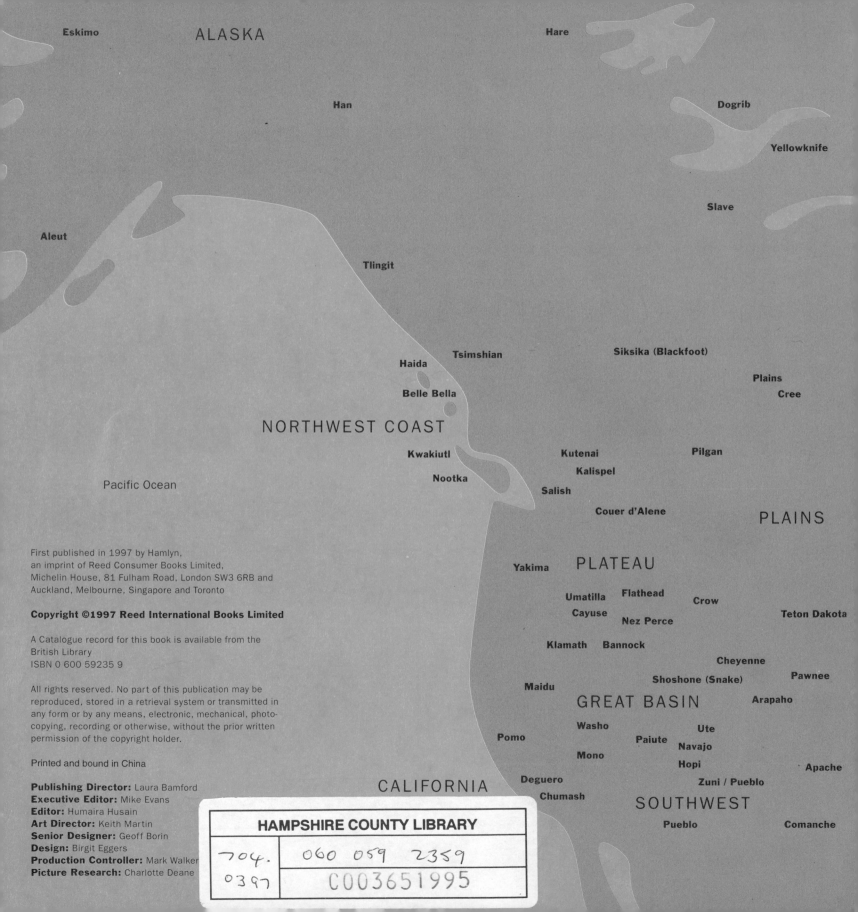

ALASKA

Eskimo

Han

Hare

Dogrib

Yellowknife

Slave

Aleut

Tlingit

Siksika (Blackfoot)

Plains
Cree

Haida

Tsimshian

Belle Bella

NORTHWEST COAST

Kwakiutl

Kutenai

Pilgan

Kalispel

Nootka

Salish

Pacific Ocean

Couer d'Alene

PLAINS

PLATEAU

Yakima

Umatilla Flathead Crow

Cayuse Teton Dakota

Nez Perce

Klamath Bannock

Cheyenne

Shoshone (Snake) Pawnee

Maidu

GREAT BASIN Arapaho

Washo Ute

Pomo Paiute Navajo

Mono Hopi

Deguero Zuni / Pueblo Apache

CALIFORNIA

Chumash SOUTHWEST

Pueblo Comanche

First published in 1997 by Hamlyn,
an imprint of Reed Consumer Books Limited,
Michelin House, 81 Fulham Road, London SW3 6RB and
Auckland, Melbourne, Singapore and Toronto

Copyright ©1997 Reed International Books Limited

A Catalogue record for this book is available from the
British Library
ISBN 0 600 59235 9

Printed and bound in China

Publishing Director: Laura Bamford
Executive Editor: Mike Evans
Editor: Humaira Husain
Art Director: Keith Martin
Senior Designer: Geoff Borin
Design: Birgit Eggers
Production Controller: Mark Walker
Picture Research: Charlotte Deane

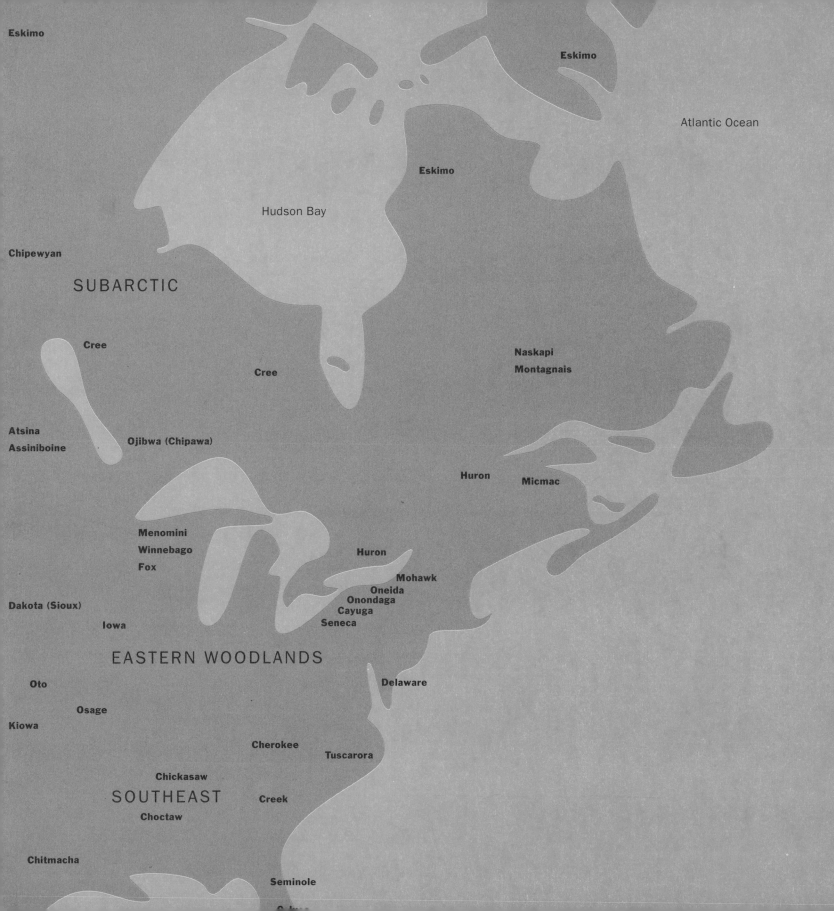

Eskimo

Eskimo

Atlantic Ocean

Eskimo

Hudson Bay

Chipewyan

SUBARCTIC

Cree

Naskapi
Montagnais

Cree

Atsina
Assiniboine

Ojibwa (Chipawa)

Huron

Micmac

Menomini
Winnebago
Fox

Huron

Mohawk
Oneida
Onondaga
Cayuga
Seneca

Dakota (Sioux)

Iowa

EASTERN WOODLANDS

Delaware

Oto

Osage

Kiowa

Cherokee

Tuscarora

Chickasaw

SOUTHEAST

Creek

Choctaw

Chitmacha

Seminole

geography of nati

history of the nativ

arctic and s

nor

trib

sout

peoples of the e

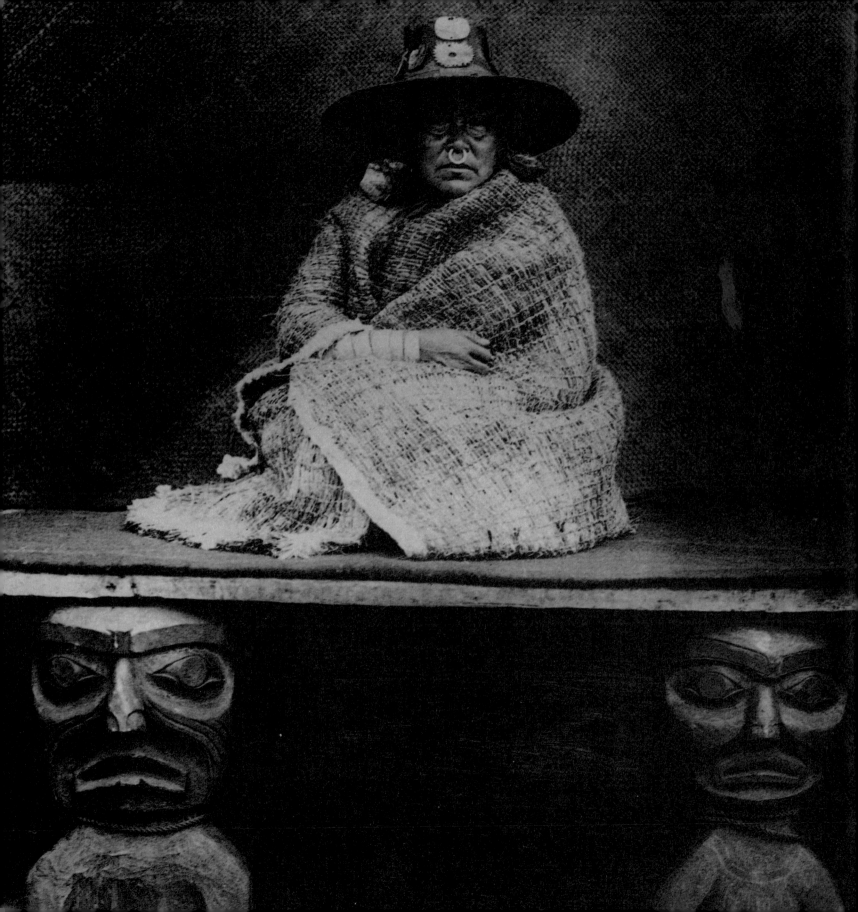

There is no word for "ART" in any of the languages of the indigenous peoples of North America. For Native North Americans, **artistic expression was not something that could be separated from everyday life.** However, it is clear from the artifacts they produced that the native peoples of North America had as much need to express their feelings, perceptions and aspirations in an artistic form as any other human beings.

When Native American artifacts were first seen by European artists, they caused quite a stir. THEY WERE ADMIRED FOR THEIR BOLDNESS, INGENUITY AND THE TECHNICAL SKILL OF THE ARTISTS. **However, this did not last.** Native American art was collected for anthropological study rather than for aesthetic appreciation. Indian artifacts were seen as cultural curios relegated to ethnographic collections. SLOWLY, NATIVE AMERICAN ART CAME TO BE SEEN MERELY AS "CRAFT."

It was, of course, vital to denigrate Native American art during the late 18th and 19th centuries. IF NATIVE AMERICANS WERE NOT SEEN AS PRIMITIVE, ABORIGINAL PEOPLES WITH NO CULTURE TO SPEAK OF, IT WOULD NOT HAVE BEEN PERMISSIBLE **to rob them of their lands, destroy their ways of life, suppress their ancient religions and herd them into reservations.**

Ironically, it was this very process that put the white man's artistic tools — paper, pencils, brushes and paints – into Native American hands. SOON NATIVE AMERICAN ARTISTS WERE PRODUCING WORK OF INDISPUTABLE WORTH, EVEN TO THE MOST EUROCENTRIC OF EYES. By the 1920s, there was an explosion of Native American art. In 1931, the Exposition of Indian Tribal Arts opened in New York's Grand Central Art Gallery to universal acclaim. It was followed by the Indian Art of the United States Exhibition in 1941. And in 1971, the Whitney Museum of American Art turned its whole building over to an exhibition called 200 YEARS OF NORTH AMERICAN INDIAN ART. With this exhibition, *Time* magazine said, Indian art had truly come of age.

Along the way, **many Native American artists had lost their tribal identity** and produced what is now called "PAN-INDIAN" ART. They address themselves to Native American themes, but not in the tradition of any one particular tribe. But there was nothing new in this. Tribes had borrowed ideas from neighboring tribes and from the Europeans they came into contact with. The wealthy tribes of the Pacific Northwest captured artists from other tribes. These slave artists brought their own influences and traditions with them. In many areas, women were obliged to marry out of the tribe, broadcasting their tribal traditions. Even before the arrival of Europeans, there was a lively trade in art objects between tribes that spread right across the continent.

However, the wholesale destruction of the Indian way of life means that it is now SOMETIMES IMPOSSIBLE TO UNRAVEL THE SECRET MEANINGS INHERENT IN THE ART OBJECTS THAT LOST TRIBES LEFT BEHIND. Artifacts cannot be fully appreciated in a vacuum. What can be said, though, is that the vast treasure house of art produced by the native peoples of North America is more than a storehouse of souvenirs and trinkets. It is the attempt of a culture to come to terms with a hostile and rapidly changing world. **As such, it is art in its highest sense.**

geography of

native north america

A Nootka fisherman of the north west coastal region; he uses a double-headed harpoon to spear seals, porpoises and salmon

In the land of the Navajo, blanket looms proliferated. In the winter months they were set up in the *hogans*, in the summer outdoors

The native people of North America are ethnically homogeneous. THEIR DIFFERENCES AND DISTINCT WAYS OF LIFE AND CULTURAL EXPRESSION HAVE BEEN SHAPED BY THE GEOGRAPHY OF THE CONTINENT.

The Aleut and Eskimo lived in small groups who survived by hunting sea mammals and caribou. THIS MEANT THAT CARVING BONE AND WALRUS IVORY WAS THEIR NATURAL MEDIUM OF EXPRESSION. Driftwood was also available in small quantities.

The Eskimos were also more open to outside influences than other Native Americans. As they lived on both sides of the Bering Straits, they were a cultural conduit to Asia. They also had contact with Europeans through the Norse colony in Greenland from the 11th to the 15th century. In the early 18th century, the Danes re-established a colony there, while the Russians began to move up the Aleutian chain to Alaska.

But while they were the first of the Native American people to come into contact with Europeans, the Eskimo were also the last to be swamped by European culture. MANY OF THEM ONLY GAVE UP THEIR TRADITIONAL WAY OF LIFE AFTER WORLD WAR II. The subarctic peoples immediately to the south had lost their traditional way of life two centuries before. They had abandoned their old semi-sedentary ways to fur hunting, craving the manufactured goods that European traders gave them in exchange for pelts.

The Indians of the subarctic regions culturally had ties to the peoples of the **north west**, who took longer to succumb. THEY WERE MORE REMOTE AND PROBABLY THE WEALTHIEST PEOPLE ON THE CONTINENT. The north-west coast is warmed by the Japanese current. Rainfall is high and the coastal strip is covered with rain forest, filled with abundant fish and game.

Inland, though, behind the coastal ranges, there is a **Plateau** that extends as far as the Rocky Mountains. It is dry and cold in winter. THE PEOPLES THERE WERE INFLUENCED BY THE DESERT TRIBES OF **the Great Basin** to the south. They developed stone tools and began rock carving. The Plateau Indians brought these tools down the Columbia and Fraser rivers and the coastal peoples used them to carve in wood.

With copious supplies of food, the tribes of the north west coast had the time to indulge in ceremonies and the production of artefacts. A wealthy upper class could even afford to support professional artists. After Captain Cook's visit to the Pacific coast in 1778, TRADE WITH EUROPEAN NATIONS INCREASED THEIR WEALTH UNTIL LATE IN THE 19TH CENTURY.

The peoples of the Plateau could not compete and, with the arrival of horses, turned their attentions to the east. The Plateau peoples adopted many of the ways of the Plains Indians.

A *wickiup*, a winter home of the Mono people of California, made of willow poles and grass, with baskets and sieves in the foreground

A panoramic view of a Pueblo village at Acoma in 1908, on the day of San Estevan, introduced with Christianity in the 17th century

The south west corner of North America is largely inhospitable. The region is dominated by mountains and deserts. Even California, with its pleasant Mediterranean climate, could only support a sparse population. However, this harsh existence meant that a desert culture was established where hunting was secondary to gathering vegetable foodstuffs. THIS LED TO THE DEVELOPMENT OF AGRICULTURE AND THE SETTLED EXISTENCE THIS REQUIRED LED ON TO THE DEVELOPMENT OF ARCHITECTURE AND POTTERY.

The Pueblo culture that grew up was strong enough to offer considerable resistance to the Spaniards. In 1680, the Pueblo revolt actually kicked the Spanish out of the South West. They returned 12 years later, though, to take back their possessions and also to CONVERT THE NATIVES TO CHRISTIANITY BY FORCE.

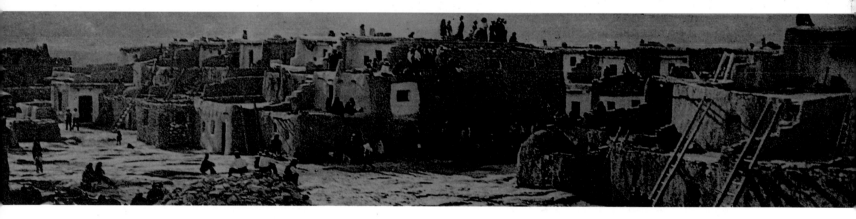

With the exception of the Appalachian Mountains, there is no major natural barrier from the Rocky Mountains to the Eastern seaboard. POPULATIONS AND IDEAS COULD TRAVEL EASILY across that vast area. In the whole area, there are only two major language groups – Caddoan-Iroquoian-Siouan and Macro-Algonquian – which took centuries to evolve.

A CIVILIZATION SPRANG UP IN THE OHIO VALLEY IN 800 BC with the 'mound-building' cultures. Huge mounds of earth were built over the graves of important people. The contents of the graves show that the arts were flourishing in that area. Local plants were domesticated and others imported from tropical America.

The centre of this culture later moved to the Mississippi valley and became refined in the **south east**. Towns grew up and the inland peoples profited from their early contact with Europeans. However, as European immigration increased, the Native Americans were seen as an obstacle to progress. The Seminole, Creek, Cherokee, Chickasaw and Choctaw – the so-called 'FIVE CIVILIZED TRIBES'— were forcibly removed to the Indian Territory in present-day Oklahoma during the 1820s and 1830s.

The tribes of the **north east** also lived in towns and grew corn and other crops. But fishing and hunting were important too. There was also considerable political organization. The Seneca, Mohawk, Tuscarora, Oneida, Cayuga and Onondaga united as the Six Nations, which put up a stout resistance to the US government's removal policy. SOME WOODLAND INDIANS HAVE MANAGED TO STAY IN THEIR ANCESTRAL AREAS AND HAVE MAINTAINED THEIR ARTISTIC TRADITIONS UNBROKEN TO THIS DAY.

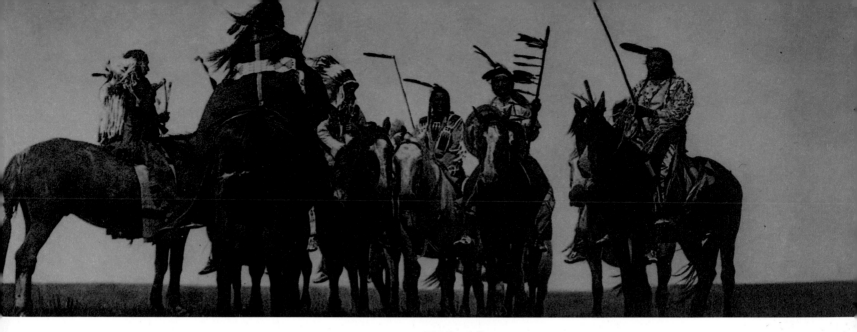

The conventional image of the Native American comes from **Plains** Indians during their resistance to the influx of Europeans. However, THE WAY OF LIFE OF THESE BISON-HUNTING HORSEMEN WAS FAR FROM TRADITIONAL. When white men first arrived on the Great Plains, the people there were settled farmers. The hunting of bison was only a seasonal activity as there was no way to follow the herds as they migrated across the Plains. But when the Pueblo revolt released a large number of horses on to the continent, Indians from all over America moved there. THEY BROUGHT WITH THEM GUNS that they had acquired from the French and the English.

These new groups had military superiority over settled tribes, and a nomadic culture based around bison hunting and raiding parties quickly sprung up. Fur-trading brought wealth and a flowering of the arts, but disaster followed. Bison were hunted to extinction and THE US ARMY CRUSHED WHAT REMAINED OF INDIAN RESISTANCE.

Atsina warriors of the Great Plains, photographed by Edward S.Curtis, a leading chronicler of native North America, in 1908

The Wichita Plains Indians erected substantial conical grass-thatched dwellings whch also served as ceremonial lodges

A governor of the Pueblo, of the
San Felipe tribe, demonstrating
the use of a drill in bead making

Opposite, a basket maker from
the Skokomish tribe of the Puget
Sound on the north west coast

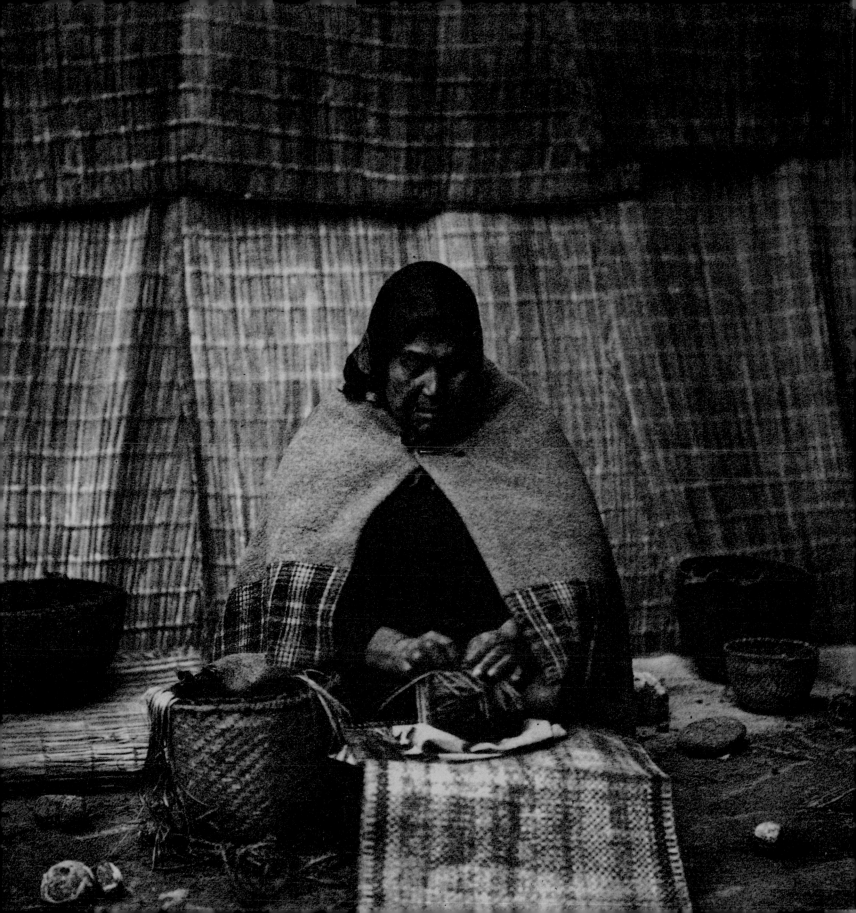

history of

native north america

A copper bird-shaped 'hopewell' found on a buriel mound in the Ohio River valley, a culture that flourished between 500 BC and 500 AD

A Pueblo cliff palace dating from the 12th century at Mesa Verde, Colorado. It housed more than 400 people in over 200 rooms

As the native peoples of North America had no written language, it is strictly correct to say that their history began in 1497, when the explorer John Cabot first set foot on the continent. However, the AMERICAN INDIANS HAD A RICH ORAL TRADITION and archaeological finds show that they had a civilization that spread back many centuries before the birth of Christ.

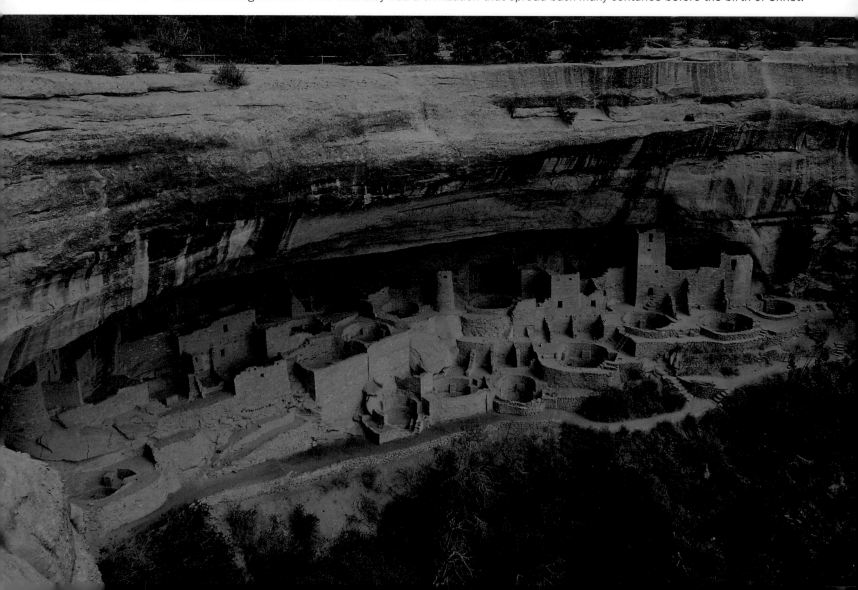

21

HISTORY OF NATIVE NORTH AMERICA

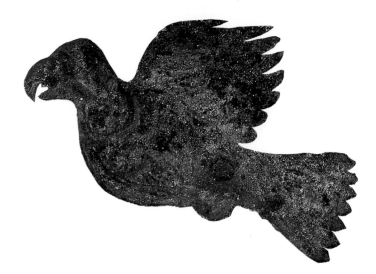

In the oral tradition of every tribe, there is a story of **'the original human beings'**. ALL THE TRIBES ARE DESCENDED FROM THEM AND THEY WENT OFF TO BUILD THEIR OWN VILLAGES IN THE AGE BEFORE THE DESTRUCTION OF THE MONSTERS WHO ONCE RULED THE EARTH.

There is some truth in this. The ancestors of Native Americans were nomadic hunters of Asian Mongoloid stock WHO CAME OVER THE LAND BRIDGE AT THE BERING STRAITS DURING THE LAST ICE AGE, 14,000 to 20,000 years ago, when the mammoth still roamed the earth. Water locked up in glaciers and the polar icesheets meant that the sea level was a lot lower then, and Asia and North America were contiguous.

The land between the continents, Beringia, was treeless and snow covered, but there was enough grass and other types of vegetation to support mammoth, bison, reindeer and caribou. Siberian hunters would have followed them as they migrated across from Siberia to Alaska. These hunters brought with them knowledge of fire, domesticated dogs and ancient healing practices. Small blades and other artefacts found in Alaska and the Yukon are similar to those found at Lake Baikal in Siberia.

The first Americans lived by hunting, fishing and gathering wild berries. They dwelled in tent-like houses. From Alaska, they spread out as far as Terra del Fuego at the tip of South America, probably within a thousand years. There were no indigenous peoples before these Paleo-Indians arrived. Their genes are mixed with no earlier race, AND NO OTHER SINGLE HUMAN POPULATION HAS SPREAD OVER SUCH A VAST AREA.

ANTHROPOLOGISTS BELIEVE THAT THERE WERE THREE WAVES OF MIGRATION. In the first wave were the **Paleo-Indians**, who were ancestors of the native peoples of South America and most of the North American tribes. The second brought the **Athapaskans**, the ancestors of the Navajo, the Apache and several tribes of the western subarctic. The third brought the **Eskimos and Aleuts.**

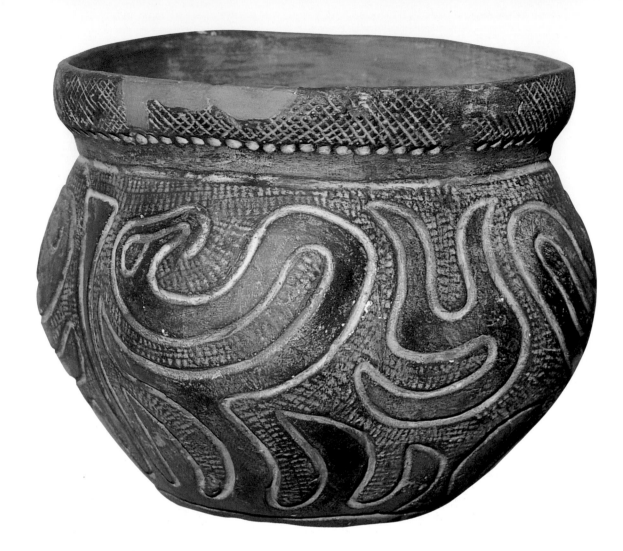

EACH WAVE BROUGHT WITH IT ITS OWN **language** – Amerindian, Na-Dene and Eskimo-Aleut, respectively. These are now the three major language groups. But by the time Europeans arrived, THESE THREE LANGUAGES HAD EVOLVED INTO TWO OR THREE HUNDRED.

There is little relationship between the languages and the cultures of Native American tribes. Often tribes who speak entirely different tongues have similar cultures, while others speaking languages derived from a common root, have completely different cultural patterns.

Around 7000 BC, the land bridge closed and the peoples of the Americas were cut off from developments in the rest of the world. No pre-Columbian tribe developed an alphabet, though the Maya, the Aztec and other Central American peoples developed various writing systems. Many of the eastern tribes of North America had mnemonic systems. The *wampum* belts of the Iroquoian peoples, for example, were used to recall events. Here and there a simple form of picture writing was used. Ojibwa bark painting depicted various sequences of events. Eskimos did the same on bone and ivory. But generally the tradition of Native Americans was oral and entrusted to those with gifted memories.

The Paleo-Indians of the Plains and the northern woodlands lived by **hunting**. On kill sites, they left behind stone lance tips and tools made from ivory and bone. When the mammoth died out 10,000 years ago, the Plains peoples turned to the bison instead. They killed them by stampeding herds into canyons or over the edges of cliffs. THE BOW AND ARROW ONLY CAME INTO USE ON THE PLAINS IN 500 AD. The woodland peoples also used snares and other traps to catch smaller prey.

Those living on the coast, along the rivers or around the Great Lakes, took to **fishing**. They used weighted nets, traps and hooks. River and sea molluscs were also eaten, along with roots, fruit and berries. COOKING WAS DONE IN THE OPEN. Food was either boiled in a wooden, bark or hide container, baked in a pit, or grilled or roasted over an open fire. Stone implements slowly gave way to copper. The earliest copper implements were found around Lake Superior and date from around 3000 BC.

Burial mound culture also produced this pot with bird figures, found in the Mississippi River Valley

A soapstone pipe *circa* 1200-1300 AD (right), found at a Spiro burial mound in Oklahoma, showing a warrior beheading a victim

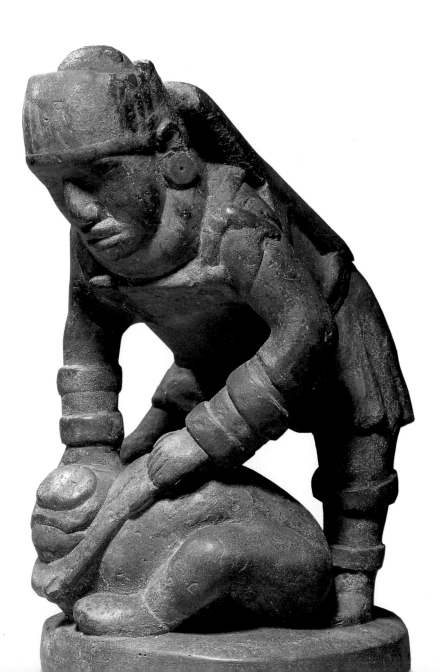

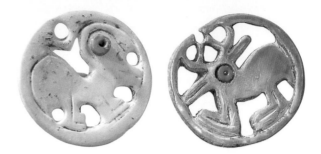

Agriculture BEGAN IN THE SOUTH WEST BEFORE 4000 BC. Maize, squash, peppers and beans were grown. Small **settlements** sprang up around the area that is now the junction of New Mexico, Colorado, Utah and Arizona. The houses had beamed roofs and wattle-and-daub walls.

Cultivation spread to the Ohio Valley in around 500 BC. BY 100 BC, SETTLED COMMUNITIES HAD BEEN ESTABLISHED BASED ON WELL ORGANIZED VILLAGES. But this fell into abeyance around 700 AD. Then from 700 to 1200 a new culture grew up in the Mississippi Valley between modern-day Vicksburg and St Louis. Large public buildings were built on raised earth platforms and villages were surrounded by timber palisades. There was an organized priesthood. Pottery was in widespread use, though before the arrival of Europeans, the wheel was unknown to Native Americans, so most pots were built up out of coils of clay. Special ceremonial costumes and ornaments were also produced.

However, with the arrival of the horse, Native Americans began to migrate out on to the Great Plains and REVERT TO A NOMADIC EXISTENCE.

Meanwhile, an agricultural culture flourished in the south west. Two major farming societies grew up – the Mogollan in New Mexico and eastern Arizona, and the Hohokam in southern Arizona. During the Pueblo period of 1050 to 1300, GREAT CLIFF HOUSES WERE BUILT WITH UP TO 1000 ROOMS. Whole villages could be accommodated. But after a long dry spell irrigation systems began to break down and, from 1300 to 1700, the cliff houses were abandoned as the Pueblo peoples migrated southwards and eastwards.

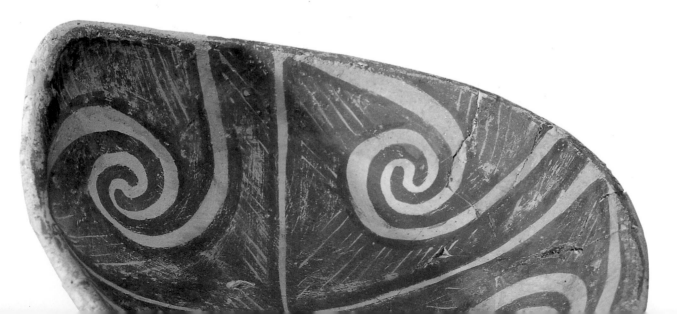

Abalone shell pendants, with bird and deer designs, from the Sinagua *circa* 1200 AD

A face embossed in copper (right) typical of the Southern Cults, 9th Century Mississippi

Detail from a pottery dish excavated at Snaketown, Arizona, the work of the Hohokam *circa* 500-900 AD

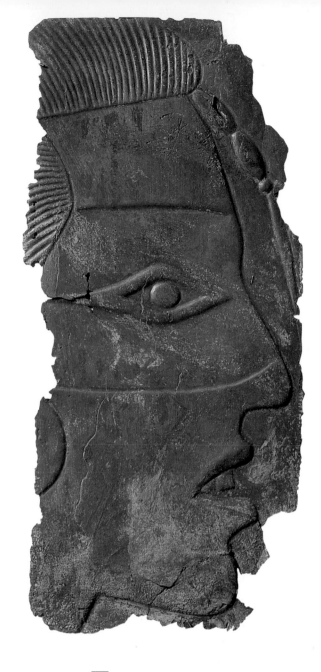

THE ARRIVAL OF LARGE NUMBERS OF **Europeans** DURING THE 17TH CENTURY SOUNDED THE DEATH KNELL FOR NATIVE AMERICAN CULTURE.

The Spanish tried to convert Native Americans to Christianity and relocated them in reserves. The French were more eager to trade with the Indians. But this distorted the economy and Native Americans began making artefacts to sell, rather than for their intrinsic value. The English stopped the confiscation of Native American lands and in 1763 proclaimed all the lands west of the Appalachians to be Indian territory. However, after the War of Independence, European immigration encroached on Indian lands AND NATIVE AMERICANS EVENTUALLY FOUND THEMSELVES CONFINED IN THE MAIN TO A MEAGRE STRIP OF LAND IN WHAT IS NOW OKLAHOMA.

arctic

and subarctic peoples

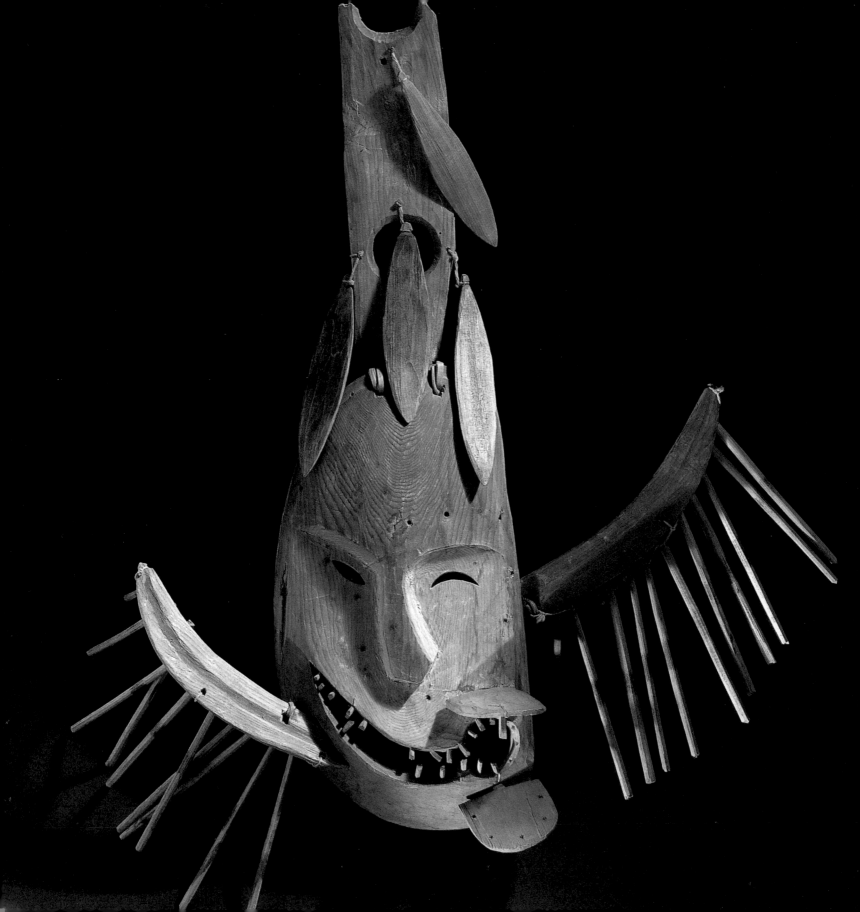

An Inuit (Eskimo) carving on a walrus ivory arrowshaft straightener, showing a scene of hunting magic shamanism

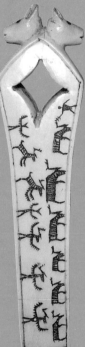

An Inuit (Eskimo) carving on a walrus ivory arrowshaft straightener, showing a scene of hunting magic shamanism

the Eskimo and Aleut peoples were dedicated sculptors. They delighted in carving bone, ivory and wood and would seize any opportunity to transform a functional object like a toggle or a hide scraper into a miniature animal or human face.

There is also an unbroken tradition from ancient times of carving non functional objects. Usually they depict the human figure or animals. But there is so little development in style and the same form is seen from the earliest artefacts found right up to the 19th century, when regular contact with Europeans allowed new styles to flourish.

It is noticeable that the Eskimo peoples paid more attention to carvings of animals than to those of human beings. This is because almost everything they ate and used came from animals. THE ESKIMOS BELIEVED THAT THEY SURVIVED ON THE GENEROSITY OF ANIMALS WHO GAVE THEMSELVES BY THEIR OWN FREE WILL TO HUMAN BEINGS. In response, people had to do everything they could to please animals and show them proper respect.

Walrus ivory and bone was also the medium Eskimos utilized for record keeping and picture writing. They used steel tools to cut the surface, even before the Europeans arrived. The process of steel making had come to them via China and Siberia. Eskimos were the first people on the American continent to use the material, and there are examples of

An Eskimo mask from south west Alaska which represents a supernatural creature. When an actor in a festival put on such a mask he became imbued with the spirit represented

steel-cut carvings that have been dated back to the first century AD. The lines were coloured with a mixture of oil and burnt grass.

This method was also used to decorate the bone armour Alaskan Eskimos wore when they went to war with their Siberian cousins. Hunting and battle scenes

are depicted on armour slates. Humans are shown as stick figures and there is some suggestion that the scenes depicted are a visual record of some particular incident that led to war.

IVORY PIPES BECAME ANOTHER STORY-TELLING MEDIUM AFTER SMOKING WAS FIRST INTRODUCED IN THE LATE 18TH CENTURY.

Although tobacco is indigenous to the Americas, it had to travel right around the world to get to the Eskimos. First it was taken back to Spain by Columbus, then the habit of smoking spread slowly across Europe and Asia. Finally Russian and Siberian traders brought it to Alaska.

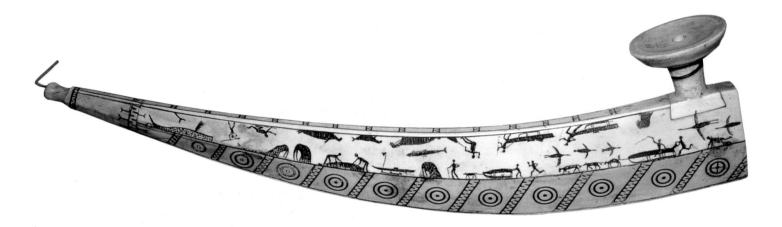

Pipes often depicted hunting scenes on land or at sea, and sometimes shamanistic rituals or myths – though there is no evidence that Eskimos used tobacco for any religious reasons, as other Native Americans did.

An Eskimo ivory pipe which features a familiar decoration of hunting scenes

A Yupic-Eskimo green and white painted wooden mask; similar masks are still carved by Eskimos to this day

MASKS were a part of religious rituals and ceremonial dances. They were carved under the direction of the shaman, and mostly depicted an Eskimo's personal guardian spirit, which was usually the spirit of his prey. Sometimes masks contained composite images and were supposed to depict a whole range of creatures and natural phenomena. Some had a hinged door which could be flipped open with a string, so the dancer could reveal the human spirit inside the animal mask.

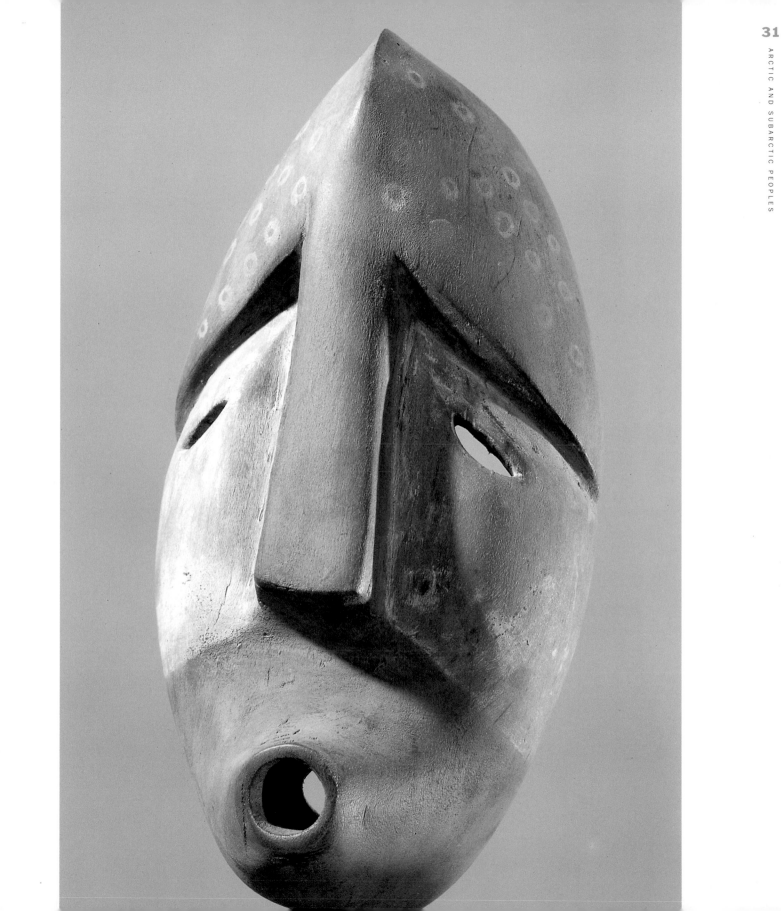

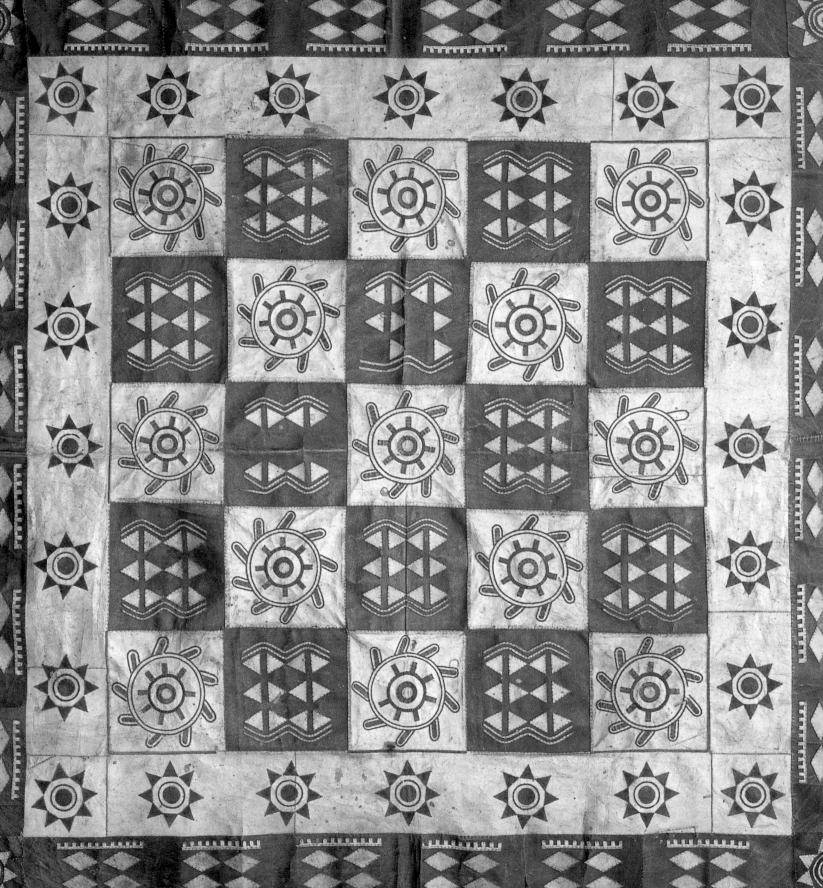

A storage bag from east Greenland, made from seagull's feet and sealskin, and depicting the sun

Opposite, a decorated Eskimo rug made from squares of animal skin

Caribou, birds, walrus, whales, seals, sea otters and fish, as well as ancestors and supernatural beings, were also represented by amulets made of ivory, bone, metal, wood or skin. Masks and amulets played a major part in the ceremonies that preceded the hunt, praising the spirit of the animal about to sacrifice its life for the benefit of humans.

Aleutian women were renowned for their basket work. Their mastery of detail shows the same precision which the men employed in their carving. The Eskimos were also great tailors, making warm clothing from fur and skins, decorating their parkas and boots with linear outlines similar to those seen on their ivory work.

A fierce-looking face mask worn in religious ceremonies by the Eskimos of east Greenland

Eskimos also carved soapstone. Traditionally they did this to make oil lamps, but in the late 19th century they began carving animals and human figures, which they sold to Europeans. The practice spread from Hudson's Bay across to Alaska and regional styles developed. The Cree to the south took up the practice too.

In the subarctic regions of Alaska and Canada are the various Athapaskan-speaking tribes – the Hare, Dogrib, Yellowknife, Slave, Chipewyan and Han – though two of the major Athapaskan-speaking tribes, the Apache and the Navajo, migrated south around AD 1000. South of Hudson Bay were the Woodland Cree and the Ojibwa (known as the Chipawa in the US). Along with the Naskapi and Montagnais of Labrador, they spoke Algonkian like the nations to the south.

The otter and the muskrat were both emblems of the Ojibwa Grand Medicine Lodge, and medicine bags were made from their pelts. They were used to carry tobacco, which was used as a part of religious rites. The bags were decorated with delicate, understated patterns, which were designed to carry a message of religious significance.

The Slave, Hare, Dogrib and Yellowknife peoples also made medicine bags. However, these were muted imitations of those made near the Great Lake, which used the French technique of ribbon appliqué.

The Athapaskan tribes made woven QUILTWORK sewn onto bags, belts, shirts, coats and moccasins. The most complex designs were by the Chipewyans and Cree. THE DESIGNS WERE GEOMETRIC AND PRODUCED WITH DIFFERENT COLOURED QUILLS, though the northern Athapaskan tribes used moosehair instead.

The Cree and the Naskapi also went in for painting buckskin. They used yellow, red, blue-green and occasionally black, to produce geometric patterns on robes, mittens, caps, bags, leggings, coats, moccasins and masks.

The subarctic peoples made containers out of birch bark, which could easily be cut, folded and stitched. Designs were produced by scraping away the darker outer layer, revealing a lighter layer beneath. Zigzag bands, dotted lines and chevrons were popular patterns, along with floral patterns and, occasionally, animal and human representations.

The Ojibwa were also practised in WOOD CARVING, traditionally making dolls and smaller items. In more recent times they have adopted the north-western tradition of carving totem poles, while incorporating local features.

Most representations of the spirits were rather sinister, given the fact that the Eskimos believed they were basically hostile, as in this wooden statuette from the north of Alaska

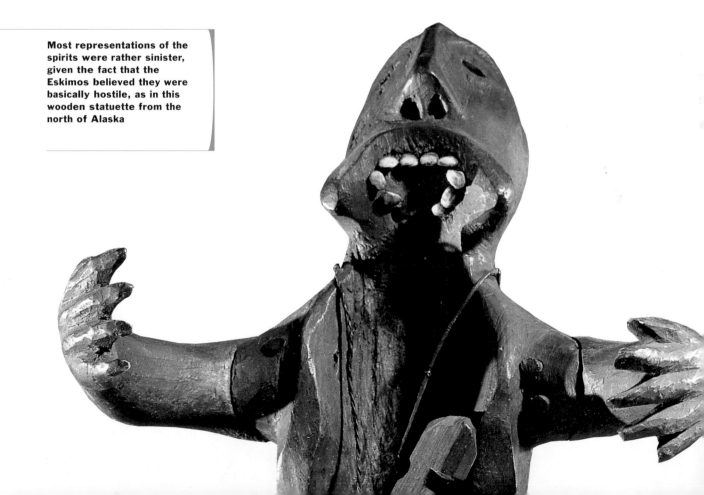

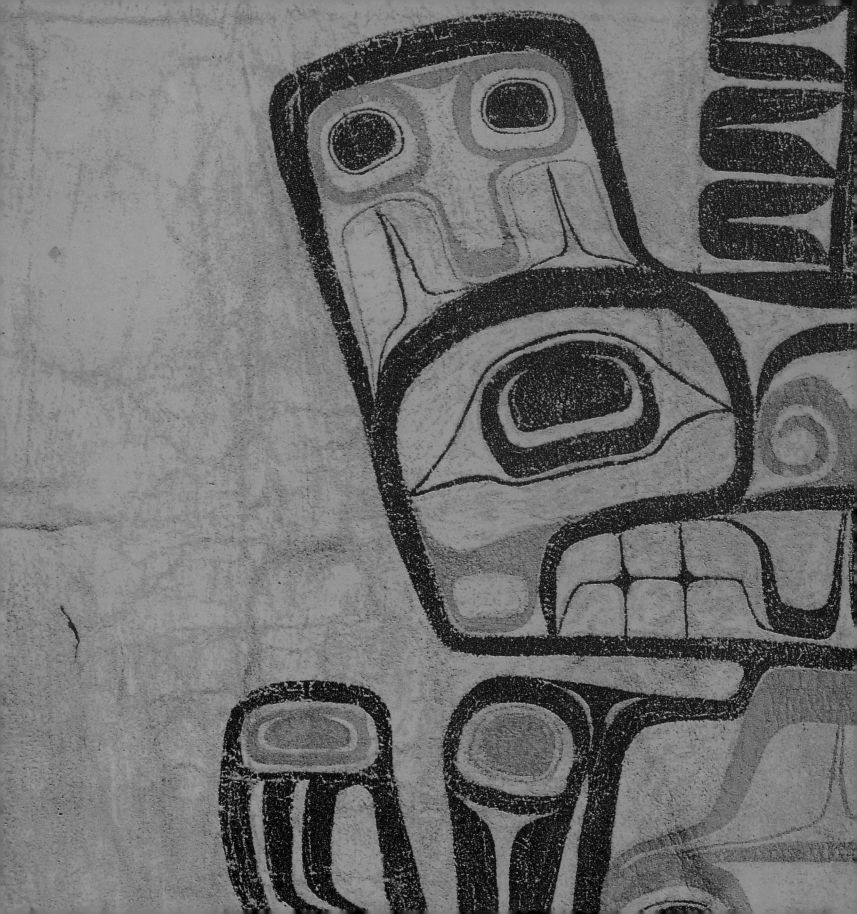

northwest seaboard

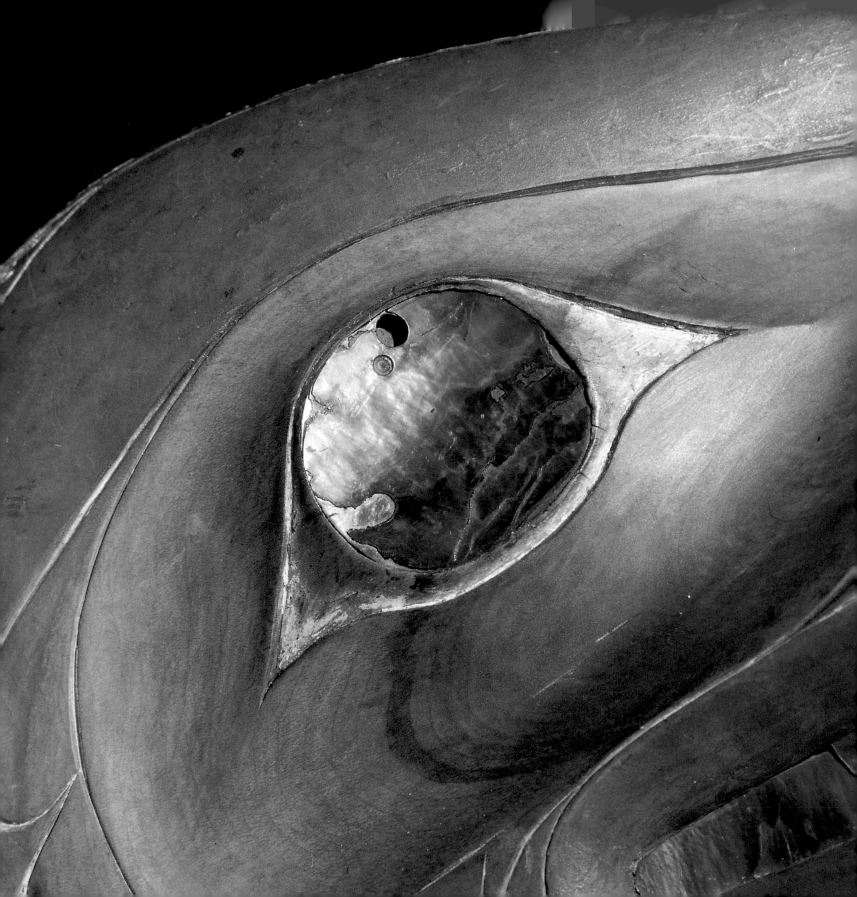

the native peoples of the north-west coast were skilled canoe builders and woodcarvers. Their most famous feat was the carving of majestic totem poles, but these were just the pinnacle of a great woodcarving tradition.

The tribes of the Pacific north west lived in huge communal houses. The largest were some 500 feet long by 60 feet wide, accomodating several related families. THESE HOUSES WERE THOUGHT OF AS LIVING THINGS, AND GIVEN THE NAME OF AN ANIMAL. Covering the doorway were carved crest poles, which looked much like totem poles but at the bottom had a round or oval hole to serve as an entrance way or exit. This entrance way was carved to represent the animal's jaws or vagina, or sometimes the 'cosmic emergence hole' through which their ancestors reached this present world.

The oldest crest pole can be seen as Gitwancool, a Tsimshian village in British Columbia. It features an elaborately carved opening which is topped by a tall and richly carved shaft.

Inside the houses there were elaborately carved houseposts and effigy columns. These were written about and sketched by early European travellers, but they made no mention of free-standing totem poles. It seems that these were a quite recent development brought about by the introduction of metal tools and the increased wealth brought to the peoples of the north west by the European fur trade.

Modern TOTEM POLES stood in front of the communal house as a family emblem. Erected as memorials to dead chiefs, they recorded the family's history back to the mythic past. Although a relatively recent development, they used images and emblems which can be traced back over 1,200 years.

A detail of the eye, inlaid with abalone shell, from a Tsimshian eagle crest helmet, the helmet being worn leaving the wearer's face exposed

Typical is a pole called 'Ensnared Bear' erected in Kitwanaga, a Tsimshian village in Upper Skeena, around 1875. The 'Ensnared Bear' on the top of the pole is the family crest and relates to THE FOLK TALE OF THE BEAR MOTHER. This tells of a young woman who slips on some bear dung out in the forest and curses the bears. Two bears overhear her curses. They kidnap her and take her to the Chief Bear who forces her to marry his son. She gives birth to twins who are half-man, half-bear. Her brother comes to rescue her. When her bear-husband realises that his wife's brother is going to kill him, he begs for time to teach her sacred songs that must be sung over a bear's dead body in order to release his spirit. Once this has been done, the bear allows himself to be killed.

Back at the village, the twins lead the bear hunts. Their knowledge of the bears' funeral rites makes them successful hunters, as other bears are happy to be killed by them, and the family take the crest of the Ensnared Bear in their honour.

A robe worn at potlaches by a high-ranking member of the Chilkat Tlingit, with the three faces of the Brown Bear and the face of the Tlingit woman who married the Bear

Made of bone inlaid with abalone shell, a Tlingit soul catcher, which was the most important tool used by the shaman when curing ills

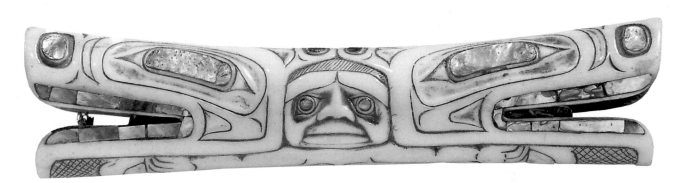

The poles were usually carved by professionals using a series of adzes and curved knives. The artist who was commissioned would sometimes hire other artists for specialist work, but maintain overall control. The finished pole would be erected in ceremony, followed by a potlatch, where the host would shame his enemies by giving them extravagant gifts.

Many totem poles were destroyed by missionaries, who imagined that they were idols which the native peoples worshipped. This was not the case. But the damp conditions of the Pacific north west meant that they rarely stood for more than a few generations. When they fell down, they were usually allowed to rot where they lay or were cut up for firewood.

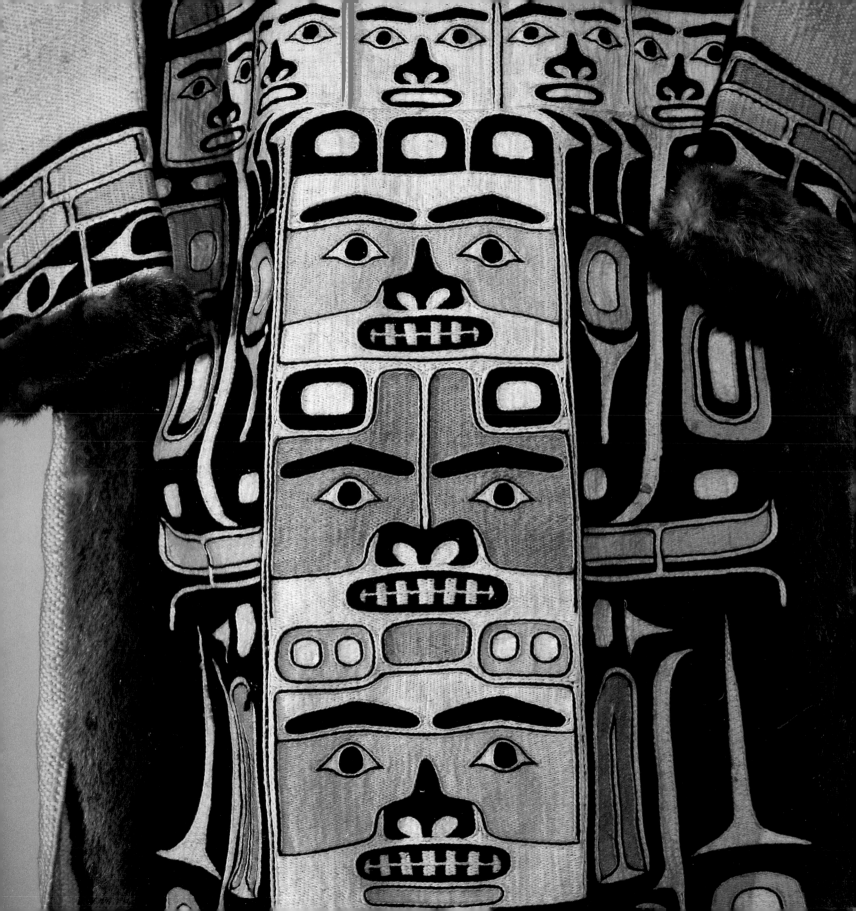

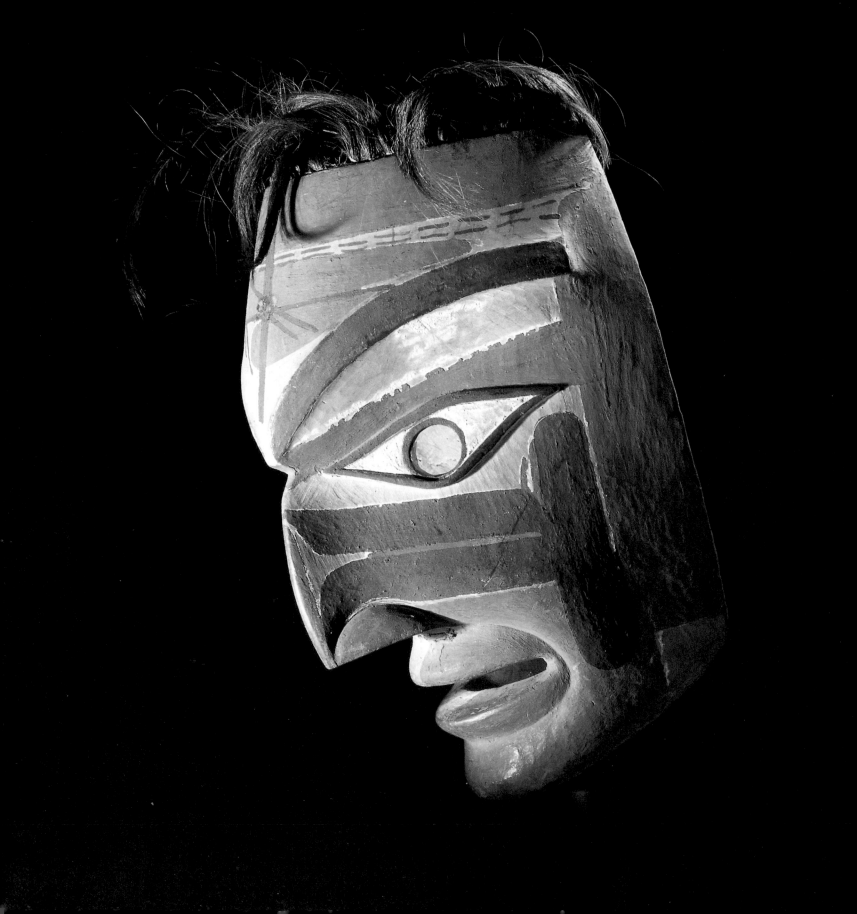

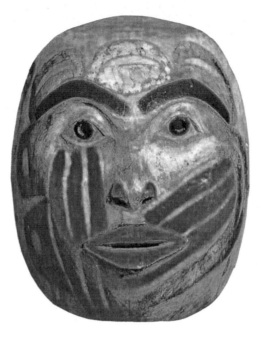

A Tlingit human face mask *circa* 1835-40, to be found in the collection of the British Museum

A wooden mask, crowned with tufts of human hair. Found in 1879 on Queen Charlotte Islands, British Columbia, although seemingly Tsimshian it has also been attributed to the Nootka

The tribes of the Pacific north west were also particularly keen on masks. When Captain Cook arrived in 1778, he wrote that the Native Americans:

'...have a truly savage and incongruous appearance; but this is much heightened when they assume what may be called their monstrous decorations. These consist of an endless variety of carved wooden masks or visors applied on the face or to the upper part of the head or forehead. Some of these resemble human faces, furnished with hair, beards and eyebrows... others, the heads of birds... and many the heads of land and sea animals such as wolves, deer and porpoises, and others. But, in general, these representations much exceed the natural size; and they are painted, and often strewed with pieces of the foliaceous mica, which makes them glitter, and serves to augment their enormous deformity... It may be concluded that, if travellers or voyagers, in an ignorant and credulous age, when many unnatural or marvellous things were supposed to exist, had seen a number of people decorated in this manner... they would readily have believed... THE THAT HERE EXISTED A RACE OF BEINGS, PARTAKING OF THE NATURE OF MAN AND BEAST...'

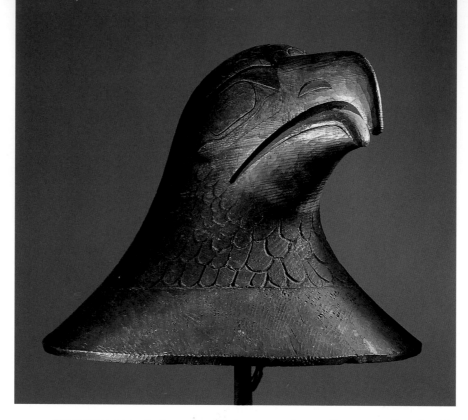

The right to commission, carve and wear masks was the prerogative of noble families. Carved from wood, these MASKS WERE DESIGNED TO EVOKE THE MYTHIC PAST. They were decorated with paint and surface carving. Human masks had hair, eyelashes, beards and movable facial parts. Those that depicted animals, monsters or birds were more elaborate, though some bird masks are reduced simply to stylized beaks up to several feet long. The masks were used in ceremonies in which key events of the tribes' mythological history were acted out.

Smaller masks, or frontlets, were worn on the forehead. They also depicted mythical beings associated with the family's fabled history. The frontlets were inherited down the female line and could be worn by women as well as men, while masks themselves were for men only.

The masks were also used in war, along with helmets that likewise carried human or animal faces. In 1802, Russians faced hundreds of Tlingit warriors wearing masks and head-dresses when they overran the fort at Sitka.

Particularly prized were conical hats, similar in shape to those seen in Asia. They had the family's emblem carved on them and, sometimes, a series of cedar bark rings on the top to signify how many ceremonies the hat had been used in. They were passed down from generation to generation.

Masks and head-dresses were often painted in bright colours, particularly a pigment made from oxidised copper which appears turquoise-blue, but turns green when oiled. Vermilion was also used. It came from China and may have been imported before Europeans began trading.

Family crests were also a feature of dance skirts and the Tlingits' famous Chilkat blankets which were made from goat's wool and cedarbark fibres. Their patterns were highly stylised and difficult to interpret, but a common image is that of a diving whale. These ceremonial skirts and blankets were treasured heirlooms and they were kept in bags made from strips of bear's intestine sewn together and stored in wooden boxes.

Other ceremonial wear included aprons of painted animal skin. This was a practise more common in other tribes outside of the north west and may have been imported later.

A Tlingit or Haida dance hat carved from wood and representing the head of an eagle

A shaman's rattle used in the form of a salmon, and containing the effigy figure of a shaman

Ceremonial RATTLES were elaborately carved, often depicting a reclined shaman with a frog riding on the back of a bird. They were often found in the graves of shamans.

The peoples of the north west coast grew tobacco. But before the arrival of Europeans, they chewed it, limiting its use to important ceremonies, particularly memorials to the dead.

The Europeans who introduced the habit of smoking brought with them clay pipes. Native Americans in the north west began carving pipes from wood or ivory. They were often decorated with family crests – frogs, bears, eagles, ravens, killer whales or mythological creations. Later, pipes were carved to sell to tourists.

the great plains

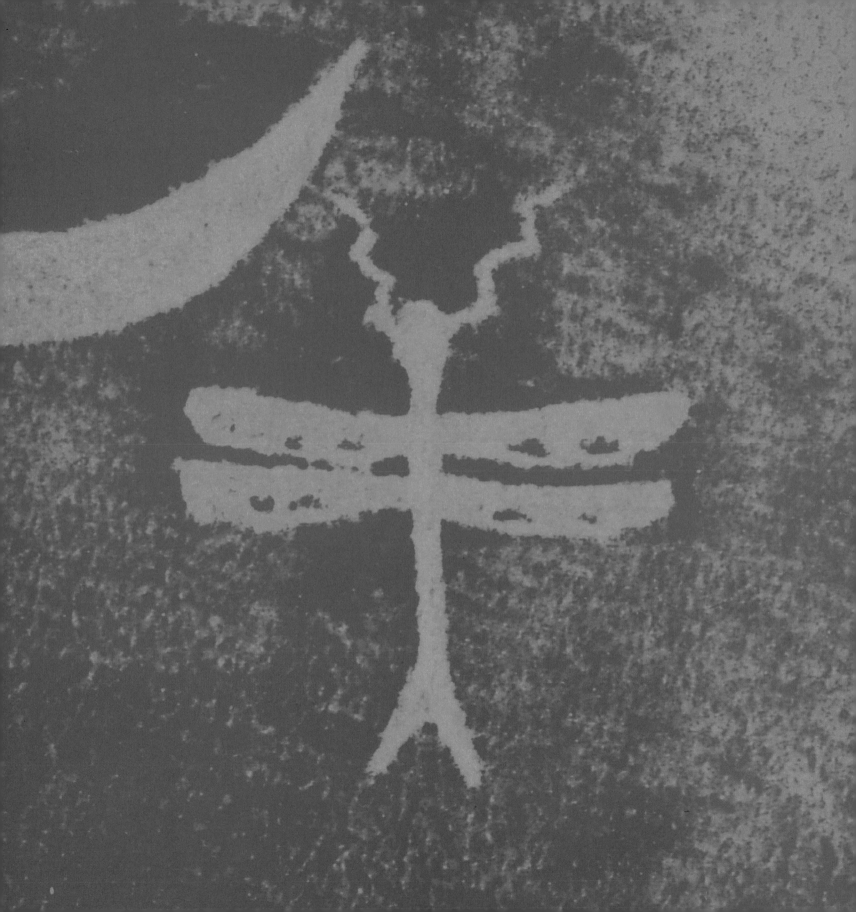

A hide shield cover showing a
bear coming out of a hole, with
bear tracks and flying bullets

Opposite, from Dakota, a drawing
of a grass dance by Turning Bear,
a chief of the Brulé Sioux

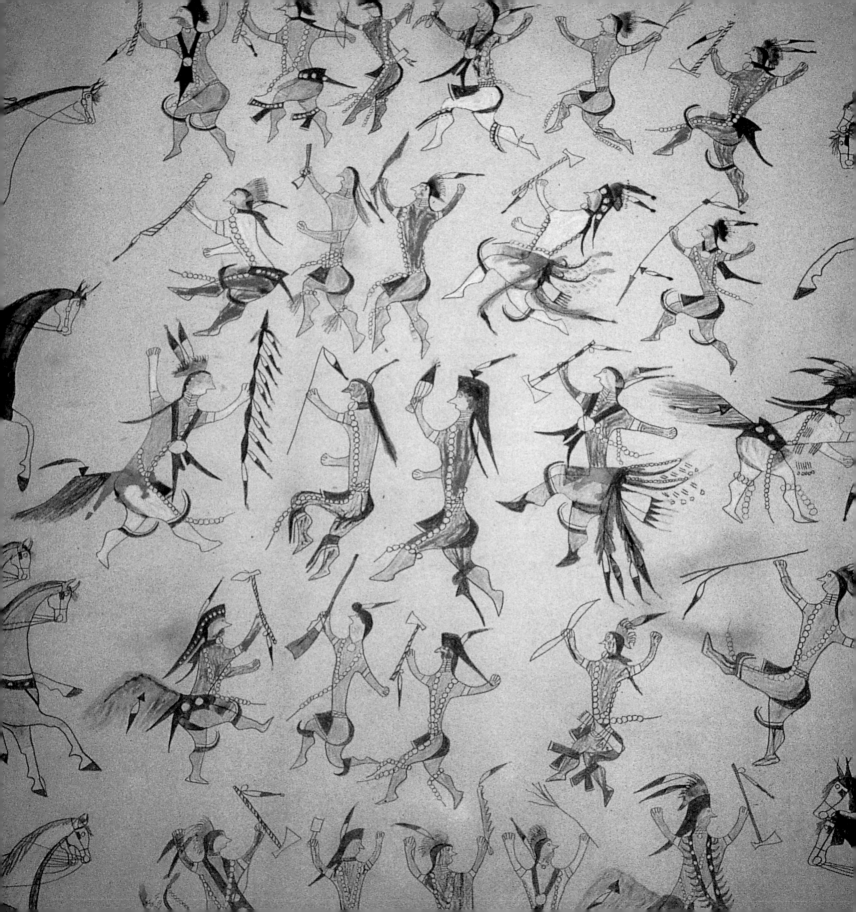

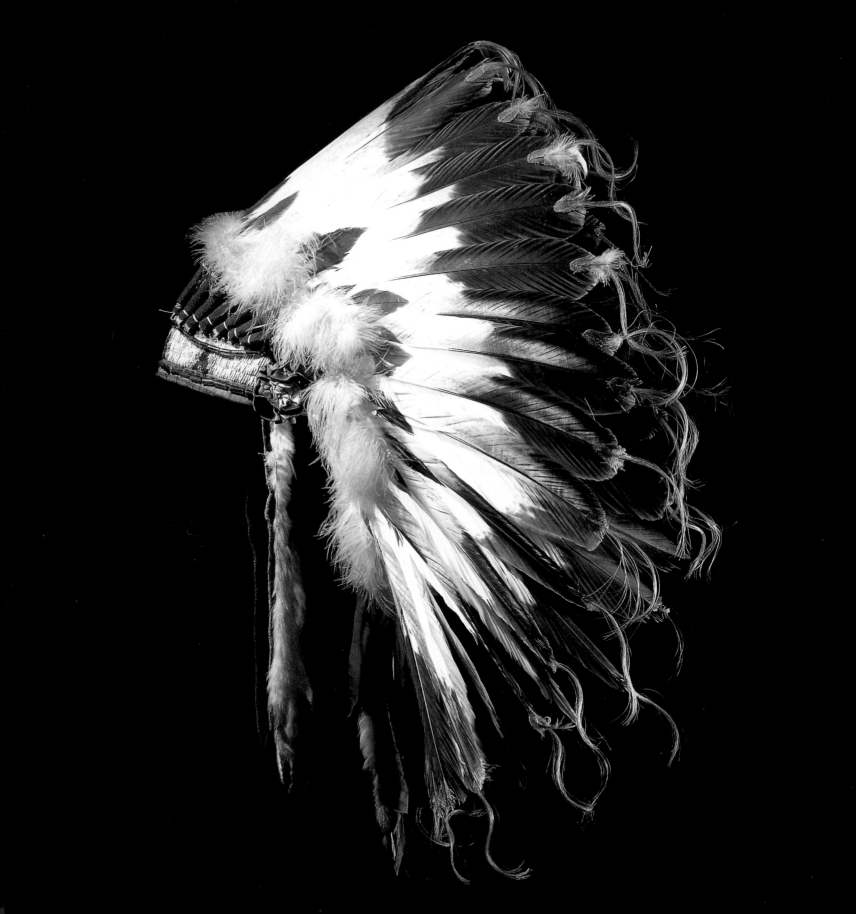

A war bonnet of eagle tail feathers which
belonged to the Arapaho chief Yellow Calf

A green quartzite effigy of a buffalo; the buffalo
was honoured as sacred, and such effigies gave
humans a measure of control over the herds

the Plains Indians are the classic Indians of the movies. THEY
WERE THE NOMADIC PEOPLES WHO ROAMED
THE GREAT PLAINS, HUNTING BUFFALO. Because of
their nomadic existence, their craft work had to be both small and easily portable
– carved and decorated pipes, small beadwork fetishes and paintings on soft
leather that could be rolled up.

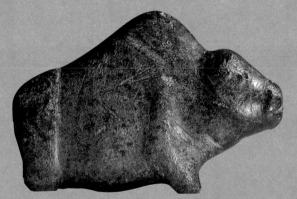

There were two separate traditions in decoration. The women produced
elaborate geometric patterns, while the men, after the immigration of Europeans,
preferred naturalistic forms.

The women honed their skills on intricate embroidery. Porcupine quills
coloured with vegetable dye and, later, glass beads were used in skilful appliqué
work. The quills were flattened and sewn onto the buffalo hide from the underside
and secured with sinew or thread. Almost every surface was covered.

In the northern Plains, the Indians preferred small beads of Venetian
glass. These coloured 'pony beads' were introduced to the area around the Great
Lakes in the 18th century by French traders who used them to buy pelts. The
Indians liked the beads so much that only a few strands bought one beaver skin.
Later smaller 'seed beads' from Venice and Czechoslovakia were introduced.

The Crow favoured large blocks of elongated triangles, rectangles and diamonds, with dark blue, green and yellow juxtaposed with lavender and light blue. The Dakota – more popularly known as the Sioux – preferred finely lined triangles, crosses and rectangles in white, blue, yellow and green.

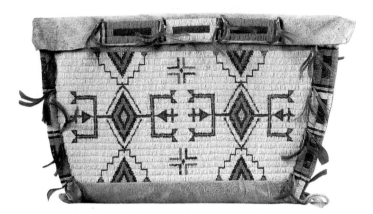

The separate male naturalistic tradition came later. Although the earliest example was in 1797, realism was probably developed after contact with European artists. Carl Bodmer, Paul Kane and George Catlin travelled across the northern Plains in the 1830–40s, painting

A beadwork saddlebag, the diamond and trident symbol representing a tortoise

Collected in 1904, a pair of feathered shields, one (right) is painted with dragonflys

the landscape and its people. They reported that the Indians were fascinated by their work and that many of them were anxious to learn more about European art.

MEN COVERED THEIR ROBES, TIPI COVERS AND WAR SHIELDS WITH SCENES FROM THEIR LIVES, HISTORY AND MYTH.

Although the human figures were often stick-like, the horses and bison were fully developed. The most spectacular form of this graphic art was narrative painting on buffalo hide. The men painted their own robes, which often proclaimed the owner's courage or skill.

The Plains artists had a broad colour palette. They made red from heating yellow ochre, their black came from charcoal, while white was produced from white clay. Blue came from a blue earth, and green was extracted from water plants. Nevertheless, despite the fact that these colours came in a number of shades, they were quickly supplanted by imported manufactured paints. Vermilion, particularly, was in great demand.

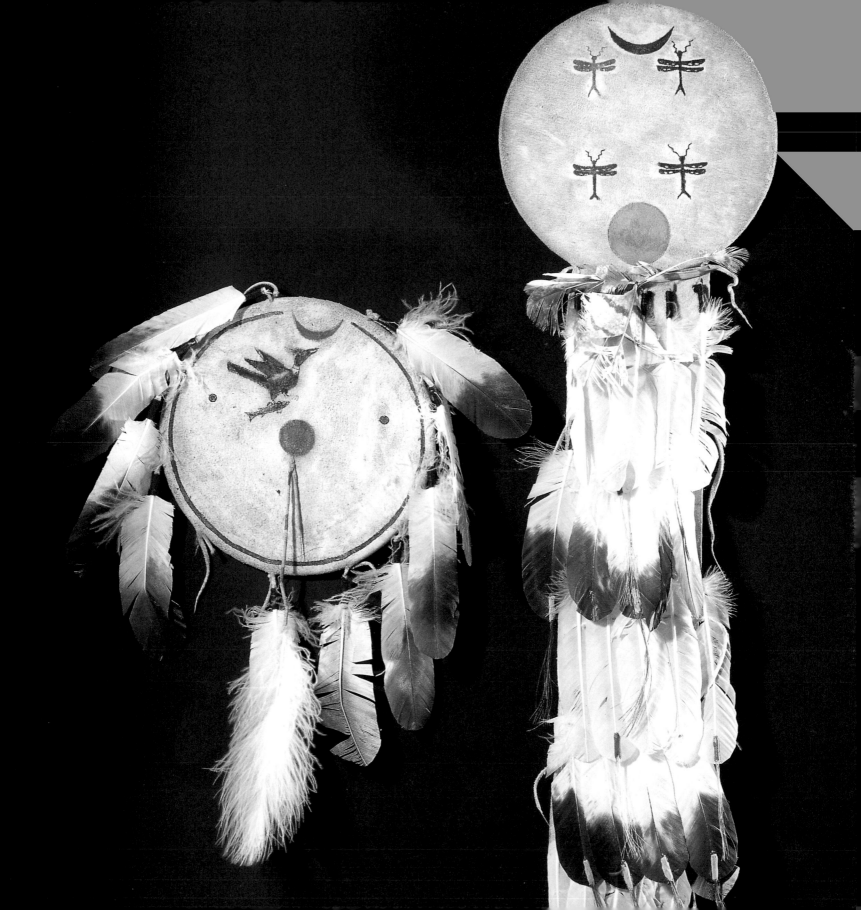

The robes were usually made from the skin of bison cows or calves as the hide of a full grown male was too heavy to wear. The hide was spread on the ground while the artist knelt beside it for anything from half a day to two weeks.

First, the designs were pressed into the skin with a small stick. Then the paint was applied with brushes made by chewing the end of willow or cottonwood twigs, or by tying antelope hair to the end of a stick. A separate brush was used for each colour. Sometimes the spongy part of a buffalo's leg bone was used. Its edge produced a fine line, while the side could be used to spread the paint evenly. When the robe was finished, women would cover their geometric designs with a

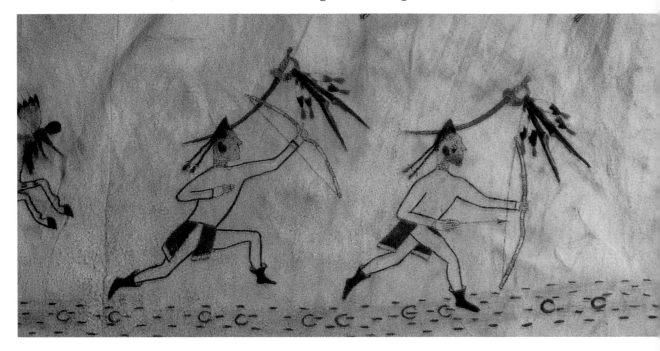

size made by boiling up the scrapings from the inside of the hide. Men left their skin paintings unsized.

Some paintings on tipis and shields come from personal visions and it is hard to unscramble their meaning, but SOME OF THE SYMBOLS ARE CLEARLY MEANT TO PROTECT THE OWNER. War shields were supposed to acquire more protective power from the symbols painted on them than from the heat-hardened buffalo hide they were made from. Also, the symbols on the Ghost Dance shirts, worn during the Plains Indians' last uprising, were meant to protect them from the US Cavalry's bullets. They did not.

Native American artists got the chance to develop their skills further when they were rounded up. In captivity, they were given paper and drawing materials to occupy their time. A Cheyenne warrior named Cohoe – Lame Man – held in Fort Marion in 1875 became quite famous. Another Indian artist held at Fort Marion

was Howling Wolf, the son of the southern Cheyenne chief Eagle Head. His work attracted the attention of white sympathisers. When he began to go blind in 1877, his white patrons paid for an operation in a Boston hospital to save his sight. Afterwards, he was returned to Oklahoma where, along with other Fort Marion artists, he began a renaissance of traditional Plains painting.

On the reservation, other Indian artists tried to depict how things had been in the old days. Plains Indians had formerly used painting to record events and the passing of the years. High Hawk, a chief of the Brulé subtribe of the Teton Dakota, revived the tradition and produced a calendar history of his people from mythical

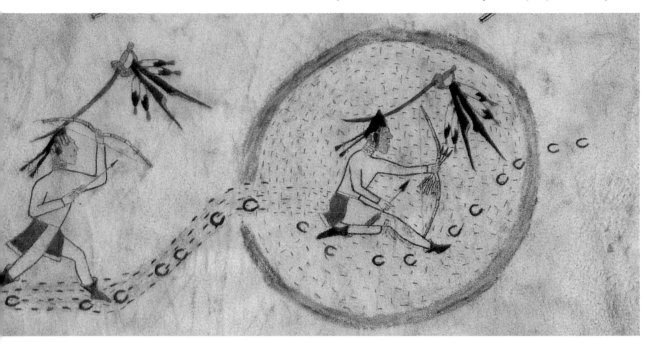

A detail from a hide painting depicting a battle between groups of Sioux and Blackfoot

times into the 20th century. And an Oglala Sioux named Amos Bad Heart Bull on the Pine Ridge Indian Reservation produced over 400 pictures of Indian life between 1890 and his death in 1913.

Around 1917, Indian Service worker Susan Peters organised an arts club for Kiowa boys. Later she enrolled them onto an arts course at the University of Oklahoma, and five of her students – Monroe Tsa Toke, Jack Hokeah, Stephen Mopope, James Auchiah and Spencer Asah – founded the 'Oklahoma School' of Indian painting.

Their tutor was Oscar B. Jacobson, a modernist. Although their subject matter was nostalgic – buffalo-hunting, ceremonial dancing, horses – he had a direct influence on the Oklahoma School's style, which was graphic and used large areas of flat colour and strong outlines.

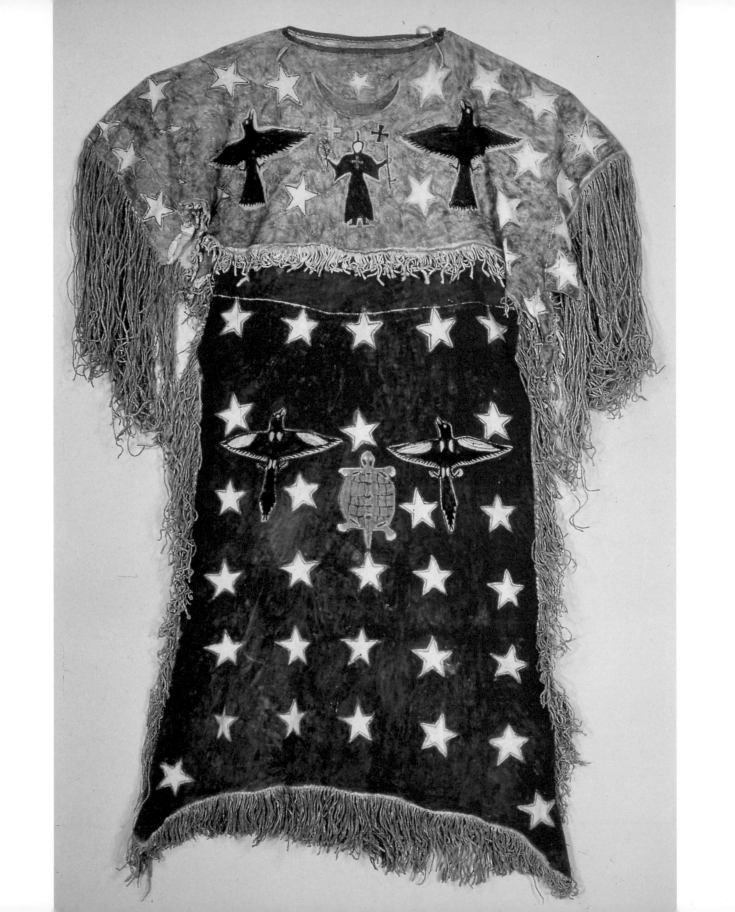

Meanwhile in the northern Plains, the influence of Bodmer, Kane and Catlin persisted. Artists such as the Oglala Sioux Roscoe White Eagle and Plains Cree Allen Sapp produced realistic art, an idealised version of how Indian life once was.

The smoking of tobacco had a ceremonial and religious significance to the Plains Indians. One pipe, made at the beginning of the 19th century, had a bowl which alone was a foot in length. But the stems were of even more importance, used as prayer wands during dances and ceremonies.

Pipe bowls were made from catlinite, a blood-colour stone quarried in south-west Minnesota at what is now the Pipestone National Monument. The sacred quarry was considered neutral ground and THE RED STONE WAS THOUGHT TO BE THE CONGEALED BLOOD OF ALL DEAD INDIANS AND BUFFALO. However, around 1700 the Sioux drove the Iowa and Oto out of the area and took exclusive control of the quarry. They maintained that long ago the Great Spirit had come to the quarry to carve himself a pipe and had told the Sioux that the pipe stone was their own flesh. Consequently, other Indians had to buy the pipestone from them.

A Sioux pipe carved in blood-coloured catlinite, in the form of a seated woman

An Arapaho buckskin 'Ghost Dance' dress, painted with a design of birds, turtles and stars

Carving pipe bowls gave Plains Indians one of their few outlets for sculpture. Human and animals were carved using flint and string saws. In early pipes, the figures face towards the smoker. Later ones, they face away – towards the enemy perhaps, who might be next to smoke the pipe of peace.

Once the idea of smelting came from the Europeans, Plains Indians began to inlay pipebowls with lead and pewter.

The stems were made by boring out a hardwood twig with a hot wire. Or the wood was split, carved and stuck back together again. A great deal of trouble went into concealing the join. Stems were often elaborate; they were decorated with beads or carvings, they were sculpted into spirals, and there were 'puzzle stems'. These looked like three-dimensional lattice work. The smoke made its way through a series of the lattice's member – but only the maker knew which path the smoke took as it zigzagged its way from the bowl to the mouthpiece.

tribes

of the plateau

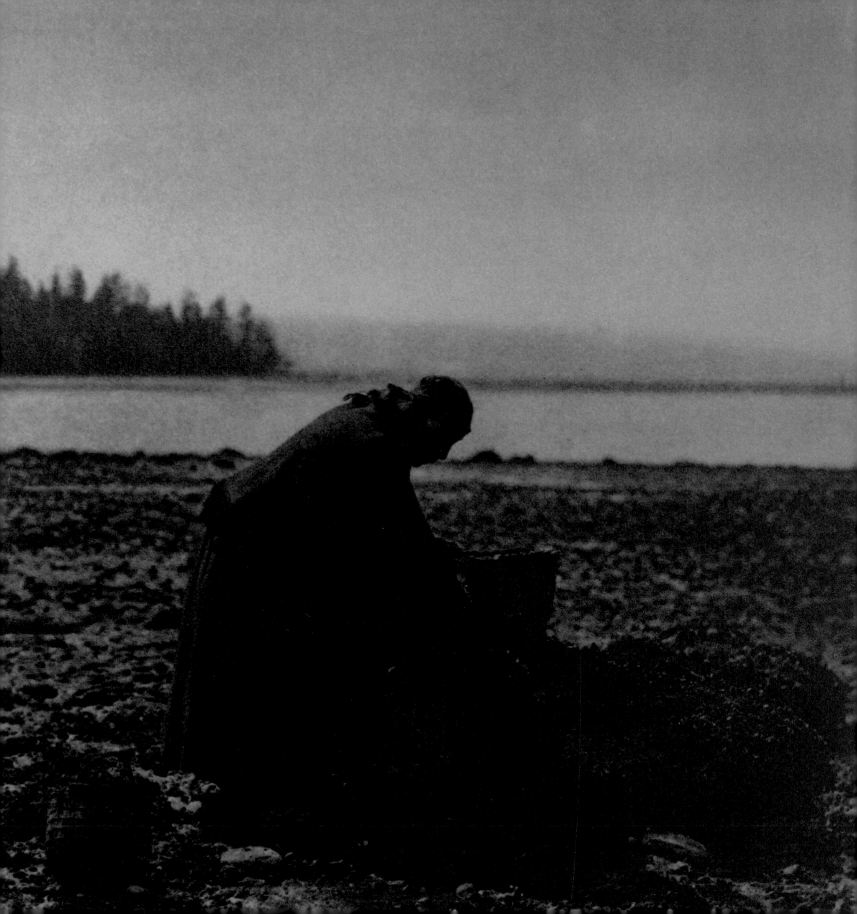

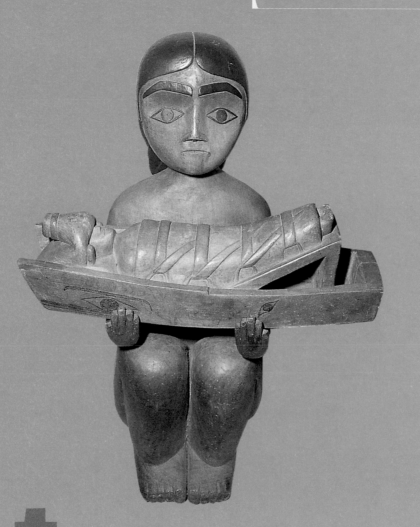

the Plateau shares a great deal with the Great Plains, but the culture there is a hybrid one. It borrowed many traits from the Native Americans of the north west coast, but many of the principal tribes – the Flathead, Kutenai, Nez Percé, Kalispel, Cayuse, Umatilla and Coeur d'Arlene – regularly crossed over the mountains to hunt on the Plains. They even acquired horses before the majority of the Plains tribes and subsequently became equestrian hunters and raiders in much the same mould. As they already represented a hybrid culture, they quickly adopted European ideas.

Clams, oysters, crabs and mussels were among the sea food diet of the Salish. Here a mussel gatherer harvests the food which was eaten cooked or raw, its shell making a primitive tool

However,what remains of their traditional culture today is very much orientated towards the Plains.

The Fraser River which cuts through the north of the Plateau is one of the sources of **PREHISTORIC STONE SCULPTURE**. Soapstone effigies from the beginning of the Christian era have been found that were still being used in historic times by the Salish tribes of the Plateau as part of girls' puberty ceremonies. By the time Europeans arrived, the Salish were carving wood in a highly stylised manner which, nevertheless, looked primitive compared with their neighbours on the coast.

The Plateau also produced a kind of soft twined **BASKETRY** that closely resembled the twined textiles of the north east. Flat 'cornhusk' bags were made of apocynum and decorated with bear grass. Cotton twine replaced the apocynum in the 19th century and dyed cornhusks took over from bear grass. And more recently wool has become the medium of decoration.

The whole surface was covered. Vivid colours and rectilinear patterns were picked out on a light coloured background, showing the influences from both the north west coast and

A steatite or soapstone tobacco pipe from the Fraser River area and dating from prehistoric times

Plains. As with similar bags that were made by tribes on the eastern seaboard, the designs on the two sides are different.

The Salish developed a **LOOM** which produced continuous lengths of fabric. These were cut up to make decorative blankets, which were the exclusive property of the nobility. A wide range of material was used. Plant fibres, wool from mountains goats, dog hair from a special (now extinct) breed, bird down and bulrush fluff were all collected and spun to use in weaving. In the early part of the 19th century, the availability of commercial yarns hugely increased the Salish's choice of colours. The patterns were geometric – chess boards, zigzags, triangles, diamonds. Sometimes these cover the whole surface, but more usually were organised in bands or restricted to the borders. For years, Salish weaving went into long decline, but recently there has been a revival in British Columbia.

The Wasco made sally bags – flexible baskets, cylindrical in shape – which carried both abstract and representational decorations on them. As naturalistic designs were rare in pre-historic Indian art, is commonly supposed that these were produced after contact with Europeans was made. However, the very first expedition to reach the Wasco in 1805 returned with a basket showing stylised human faces and animals.

Many Native Americans painted their faces and bodies, but the Thompson tribe of the northern Plateau used a distinctive 'negative' technique. They painted large areas in solid colour, then scratched patterns in it, deer jaws being used to produce patterns in parallel lines. Painting was usually done by the person wearing it, using a bowl of water as a mirror, until Europeans introduced the manufactured looking glasses. In the late 19th century, the Yakima and other Plateau tribes followed the Plains trend to making realistic images of humans, animals and plants in pictorial beadwork. Their use of colour was outstanding.

A typical example of the basket work from the peoples of the Plateau, this is an artifact of the Salish tribe

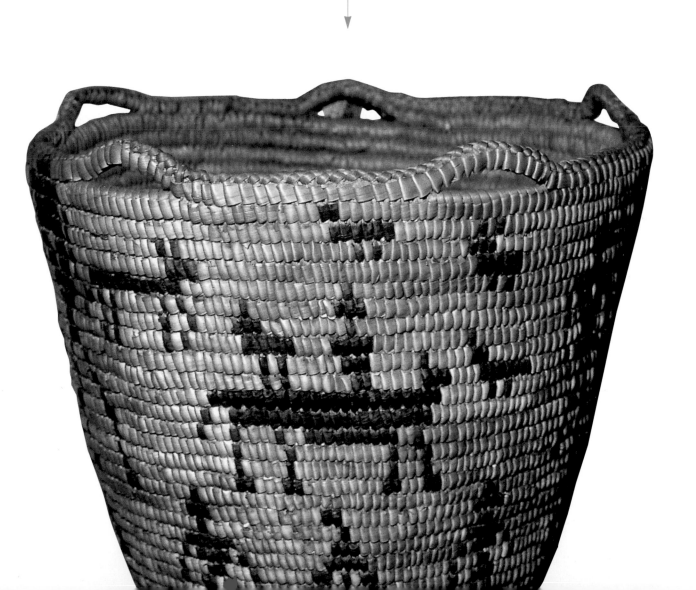

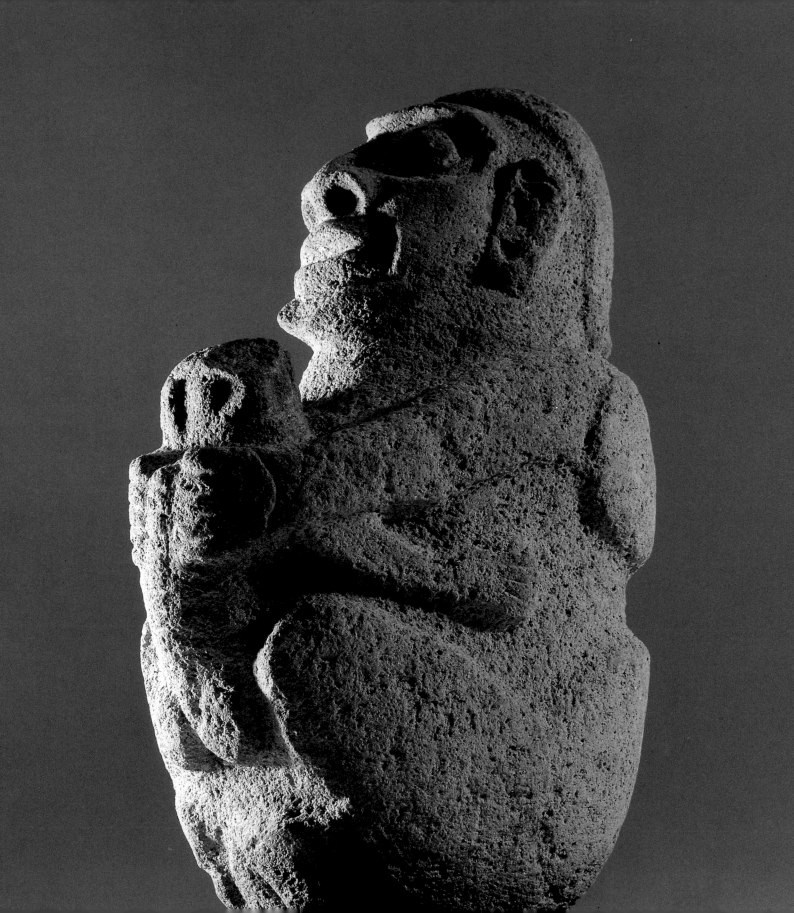

A spindle whorl as used by the
Salish in their spinning, showing
a human figure, birds and an otter

Opposite, a stone double-image of
a nursing mother (from the side)
and a figure with an erect phallus

the great basin

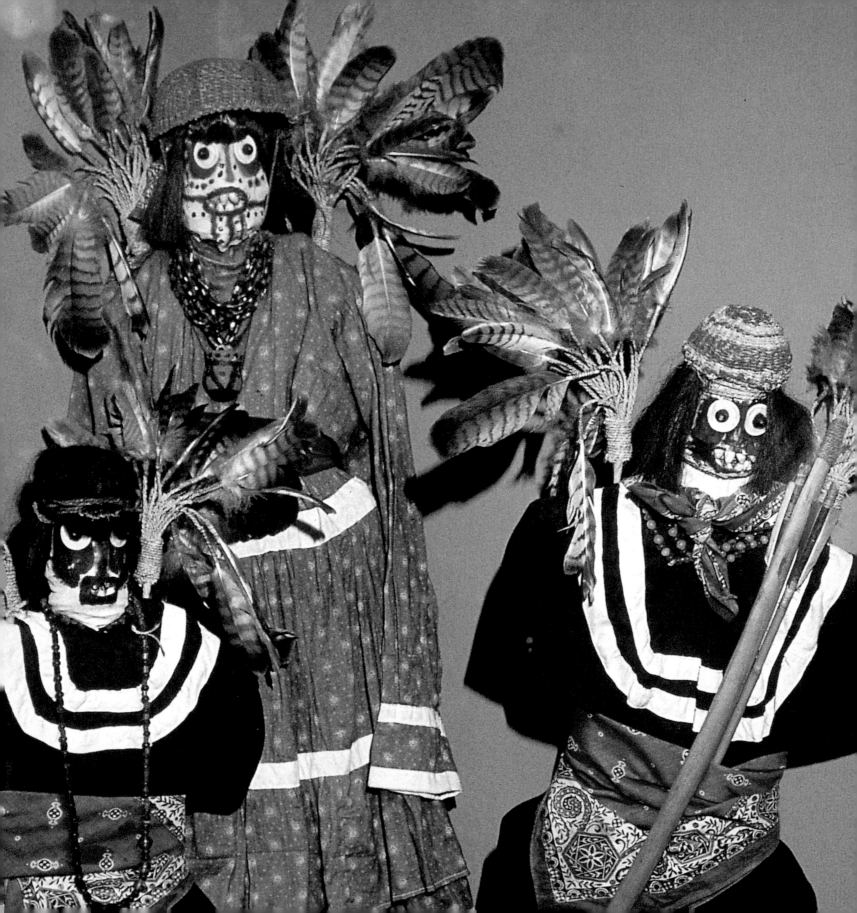

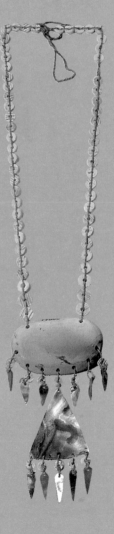

ife was hard in the Great Basin; AN UNFORGIVING DESERT, THE NOMADIC SHOSHONE, UTE AND BANNOCK SCRATCHED AN EXISTENCE THERE. Their principle source of food was jackrabbits, whose pelts were used for clothing. Other than that, the Indians there depended on mice and insects – especially locusts – along with berries and pinon nuts.

The people there had no tribal structure. Families would migrate to the surrounding mountains during the summer when the sun parched the valley floor. In winter, they would return to the valley to escape the snows.

The Indians of the Basin also borrowed from the Plains Indians. The Shoshone practised skin painting in a representative style to sell to tourists. The Ute also painted on buckskin in a style borrowed from the box-and-border robes produced by the Santee Dakota. However, where the Dakota used the motif of a stylised bison, the Ute substituted a geometric shape, invariably a hexagon.

The Mono and the Washo peoples made netted BEADWORK COLLARS, while the Paiute used netted beadwork to cover the outside of their baskets. The Paiute, particularly, were famed for their woven fur textiles.

The Klamath wove baskets like the Indians of the Plateau immediately to the north, but used a full-twist, rather than a half-twist, overlay. However, the

Funerary effigies, used in the *wikurak* ceremony by the Deguero people of southern California

most highly praised of the Basin's basket weavers were the Washo, whose coiled style borrowed extensively from that of the Apache. One particular basket maker, Datsolee, who died in 1925, was famed for finely stitched baskets, boasting over 200 stitches per inch. They featured a variety of traditional motifs, usually used repetitively, and were made specifically to sell to white Americans or Europeans.

Californian Indians excelled in basket making. Their hanging baskets were decorated with feathers, clam shell beads and shapes cut from abalone shells. **THEIR INSPIRATION WAS SAID TO COME FROM ANOTHER WORLD AND THEY SOMETIMES HAD A RELIGIOUS SIGNIFICANCE.** The colours of the feathers were symbolic. Yellow larks' feathers meant love and fidelity, the red feathers of the woodpecker symbolised pride and courage, black quail feathers meant love and beauty, green ducks' feathers showed caution and discretion, blue jays' feathers trickery and cunning, and white clam shell meant wealth and generosity.

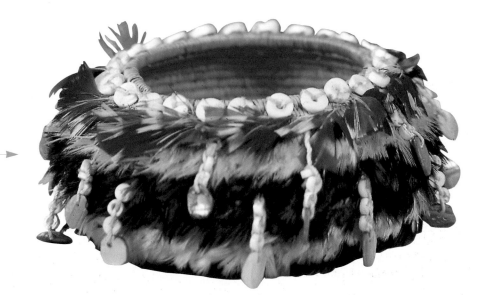

THE MASTERPIECES OF BASKETRY WERE CREATED BY WOMEN OF THE POMO TRIBE. They were called 'jewel baskets' and were presented to women at puberty and on marriage. Their intricate woven patterns were hidden behind mosaics of coloured feathers. On a woman's death, her highly prized baskets were burnt with her, which appalled the Europeans who wanted to collect them.

A treasure basket – or 'jewel basket' – of the Pomo tribe, covered in multi-coloured feathers

Pomo women were so proud of their basket-making skills that they used the most highly decorated baskets for everyday use. They also showed off by making tiny miniature baskets, reproducing all the features of a full-sized basket in one measuring an inch across.

While basket making was an exclusively female occupation, men of the Chumash tribe took to rock painting, usually while under the influence of the powerful hallucinogenic plant Datura inoxia. They painted the walls of caves during religious ceremonies.

Some of the subject mater is representational but highly stylised. Most is just an hallucinogenic maze of zigzags, chess boards, ladders, parallel lines, triangles, circles, chevrons and various other geometric shapes. While some of these shapes seem to have been symbolic, others can be tied directly to the intake of hallucinogenic chemicals.

The last Chumash rock paintings were made in the 19th century, BUT SADLY, THERE ARE NOW NO MORE CHUMASH AROUND TO EXPLAIN THEIR MEANING.

The full splendour of Pomo basket making, with its lavish decoration of feathers, clam shell beads and abalone shells

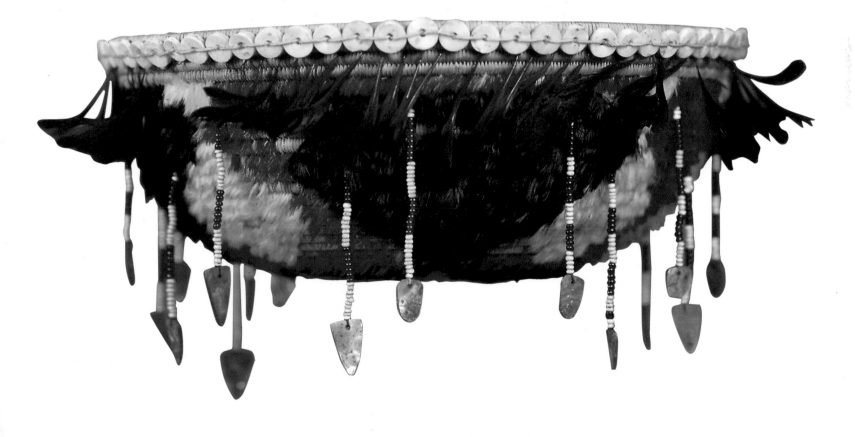

southwestern

tribes

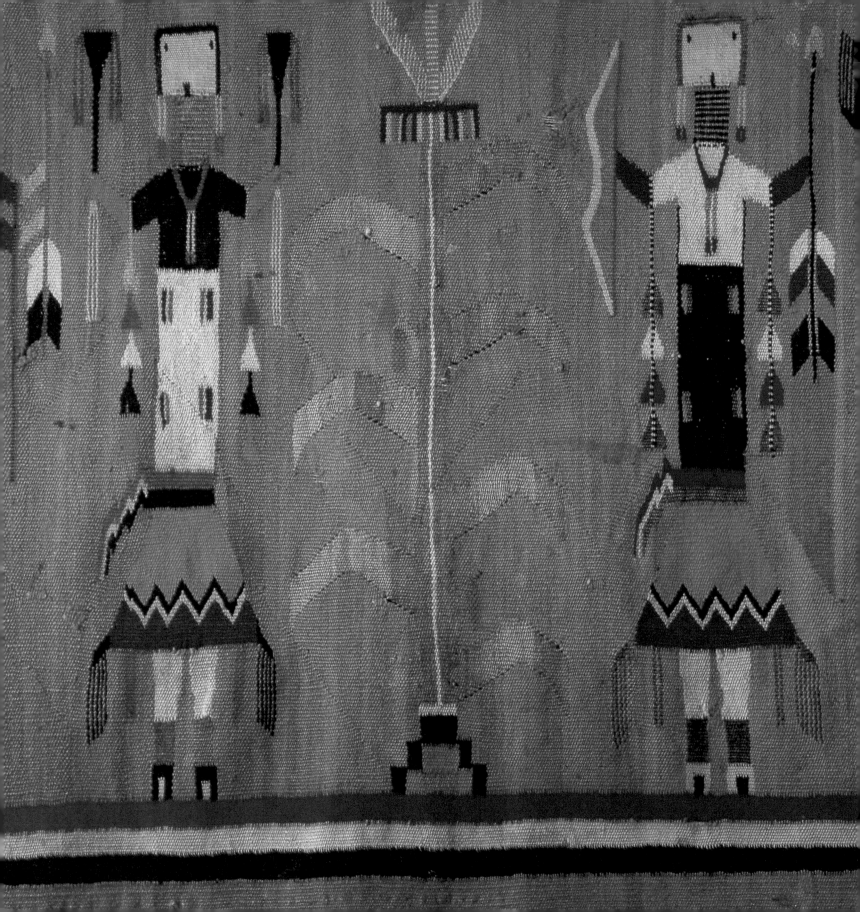

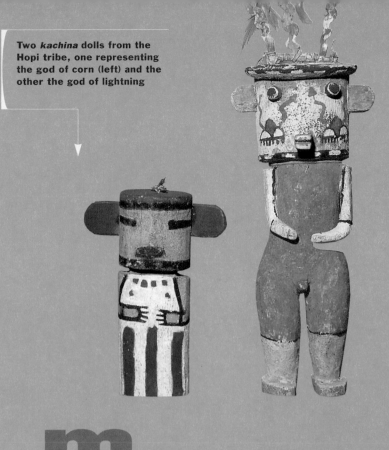

Two *kachina* dolls from the Hopi tribe, one representing the god of corn (left) and the other the god of lightning

m

any of the Native American peoples of the south west are related to the more highly developed cultures to the south in Mexico and beyond. The Hopi language is distantly related to those spoken by the Aztecs and one of their traditional *kachina* effigies resembles the old Mexican earth and rain god Tlaloc.

Although these *kachina* effigies were given to children, they were not dolls. THEY WERE THE EARTHLY REPRESENTATIVES OF THE SPIRITS. The same spirits were represented in masked and costumed figures in ceremonies and painted on the walls of the *kivas* – the semi-underground chambers from which the Hopis believed that their primordial ancestors had first emerged.

A 19th Century Navajo blanket based on a sand painting, showing two supernatural 'holy people' flanking the sacred maize plant, which was their gift to mortals, enclosed by the arc of a rainbow

Kachinas were carved by Hopi men from pieces of dried cottonwood root. They were cut to size with a hand saw, then carved into shape with a hatchet, chisel, knives and rasps. Arms and parts of their costumes were carved separately and secured with pegs.

The finished doll was sanded and covered with a fine clay paste, then painted. The mineral and vegetable pigments once used have been replaced, first

by opaque watercolours and poster paints, now by acrylics. They were given to children to teach them about the spirit world.

While the men made the *kachinas*, the women weaved BASKETS. The Native Americans of the south west believe that basket weaving was one of the arts that the gods taught women at the beginning of time. Baskets were used for carrying and storage as well as moulds for pots. But they also had their religious uses. For the Apache, who were the master basket makers, woven bowls played an essential part in women's puberty rites. The Navajos on the other hand had sacred wedding trays, while the Hopis believed that no man could enter the underworld without his flat-coiled 'wedding plaque'.

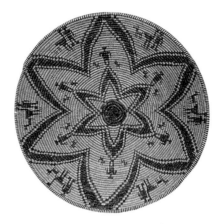

Baskets were woven from yucca and grass, and then coloured with either mineral or vegetable dyes, commercial dyes making little impact.

An Apache woven bowl or basket, decorate with images that include people, dogs and horses

A red and blue Navajo rug made of Germantown yarn and dating from around 1880

Although the patterns have natural names – 'turtle', 'coyote tracks', 'deer in the woods' – they are usually too stylized to be recognisable. Swastikas are common. Occasionally, though, people, horses and even camels – unsuccessfully introduced to the south west by the US Army – appeared, especially on early Anasazi basketry.

It was the other newcomers to the area, THE NAVAJO, WHO RAISED TEXTILE WEAVING TO AN ART FORM. The Anasazi used finely spun yucca or hemp, while other Native Americans in the south west mountain used sheep's wool, rabbit fur, feather, plant fibres and cotton, which was introduced to the region some two thousand years ago.

The Navajo started raising sheep when they were introduced by the Spanish around 1600. They learnt weaving from the Pueblo Indians who had

sought refuge in Navajo strongholds after their unsuccessful rebellion against the Spaniards in 1680.

When European cloth was introduced, Navajo women unravelled it and used the thread as raw material. Blankets were the Navajos' speciality. The classic period is considered to be the second half of the 19th century. Early designs were much the same, but only fragments have survived. But by the end of the century, Navajo blankets were being made for sale to Europeans. Increasing commercialisation soon led to a lowering of standards and traditional patterns gave way to pictures of trains, houses and American flags.

SANDPAINTING IS THE UNIQUE ART OF THE NAVAHO – though the 'painting' is not done with sand, but rather on a bed of sand that has been smoothed flat with a weaving batten. THE ARTIST IS A MEDICINE MAN AND PAINTING IS DONE AS PART OF A HEALING CEREMONY.

To the Navajo every illness has a spiritual as well as a physical cause. First the nature of the spiritual origin of the ailment has to be determined. Then a medicine man who knows the appropriate rites is hired.

The curative ceremony consists of a series of rituals, chants – each of which contains hundreds of songs – and sand paintings. There are four to five hundred different paintings, and every detail of the rituals, songs and the sandpainting must be adhered to if the cure is going to work.

The ceremony takes place inside a *hogan* – a traditional eight-sided dwelling – which has been specially consecrated for the occasion. Ornate prayer sticks, food, tobacco and turquoise are placed in front of the *hogan* to propitiate the gods. The patient is given spiritual guidance, treated with curative herbs and purified with a sweat bath. A series of ceremonies become progressively longer and more complex on successive nights.

On the fifth day, the sand painting begins. The medicine man takes mineral pigments mixed with ash in his palm. He trickles the mixture between his first and second fingers, guiding it with his thumb. Women are depicted in yellow and white, men in blue and black. Then costumes, weapons and sacred symbols are added. The subject matter is always the magical deeds of the gods.

Sandpaintings can be as small as 1ft square, or as big as 18ft across, filling the whole floor space of the *hogan*. Complex figures can have as many as six layers of colour. By nightfall, the painting must be completed. Then it is destroyed, taking with it the spiritual malaise and leaving the patient well again.

In 1919, a famous medicine man named Hosteen Klah – which means 'the left-handed one' – agreed to translate a sandpainting into tapestry. By doing this, he was violating two taboos. He was making the sacred image permanent, when it depended for its power on being destroyed. He was also translating the male art of sandpainting into the female art of tapestry.

Hosteen Klah only got away with breaking these taboos because of his status as a *nadl* – a man-woman, which is a respected status in Navajo society. And he had to be satisfied that his work would hang on a wall – and not lie on the floor where the gods could be walked on.

Navajo artists now do sandpaintings on boards, so that they can be sold. But to avoid sacrilege, they alter small details to render the paintings useless for ceremonial purposes.

The Pueblo Indians also practised sandpainting in a simpler form, and may well have taught the Navajo when they first moved to the south west. They certainly introduced the Navajo to turquoise, which the ancient Hohokam peoples had been mining and selling to the Aztecs from prehistoric times. Along the Rio Grande, the Pueblo

A squash blossom silver and turquoise necklace crafted by the Zuni people of New Mexico

Indians continued the Hohokam tradition of making complex inlaid mosaics using turquoise and jet.

The Navajo learnt metal working from the Mexicans. They perfected their skills in captivity, following their defeat at the hands of Kit Carson. On their release, THEY TOOK TO SILVERSMITHING AND PERFECTED THE ART OF SETTING TURQUOISE IN SILVER – an art they passed on to the Zuni.

The Zuni are also known for their POTTERY. This was produced by Zuni women and had sacred significance. POTS AND BOWLS WERE CONSIDERED LIVING BEINGS. The pattern on them always begins with an encircling line, but is broken so that the spirit of the vessel and anything it contained could escape. Closing the line would also signify the closing of the potter's life, meaning she would die.

Zuni women potters made breast shaped canteens for their men, with the nipple as a spout, but this was impractical so the spout was moved to the top.

Pottery has a long tradition among all the Pueblo peoples, with different tribes developing their individual styles. The Santa Clara, for example, prefer blackware, while the Acoma are famed for the thinness and delicacy of their work.

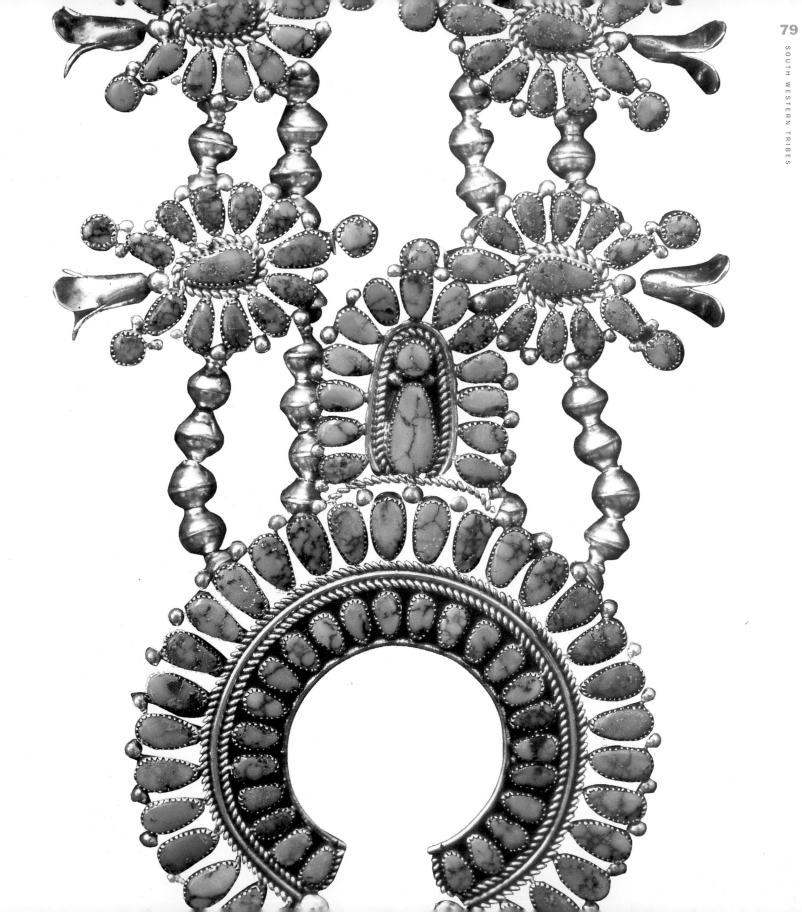

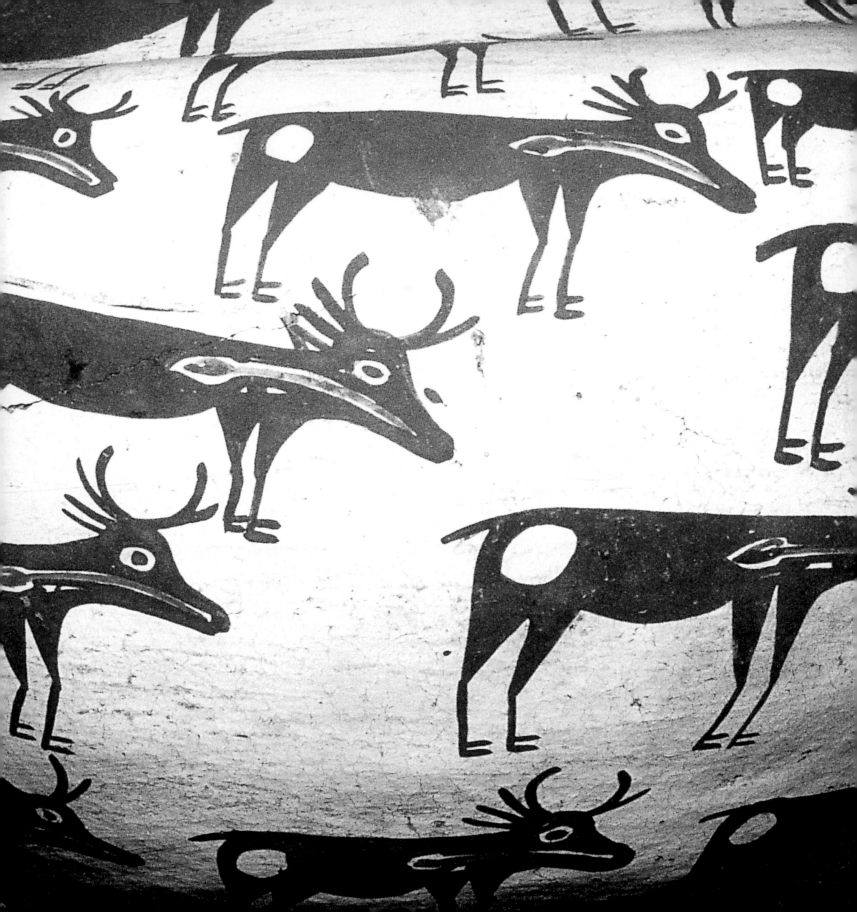

An extravagant pot decorated
with bird designs, from the Zuni
tribe of Pueblo Indians

Opposite, a detail from a
Pueblo/Zuni pot showing deer.
Note the red lines guiding the
hunter's arrow to the heart

peoples of the eastern

woodlands

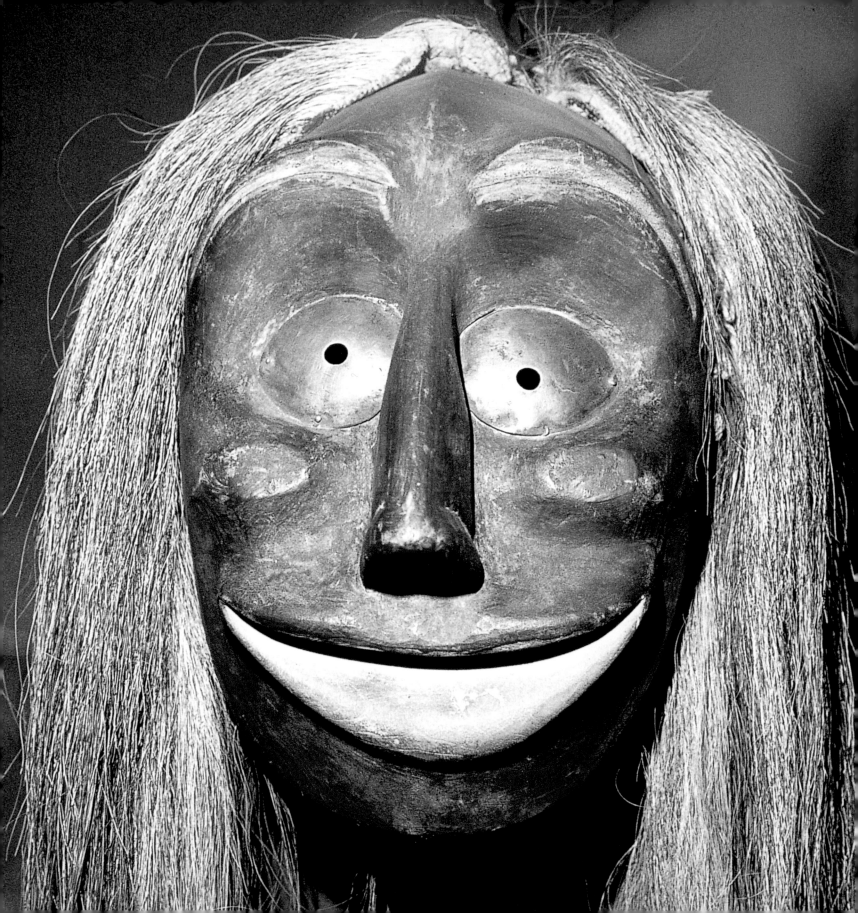

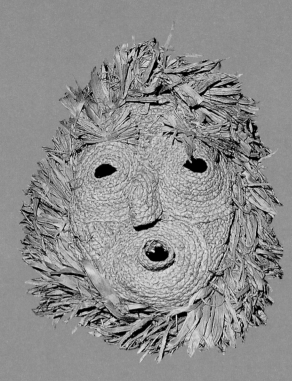

the Native Americans of the eastern woodlands were the first to have their way of life destroyed by mass European immigration. Like other Native Americans, they were great mask makers. Men carved wooden masks, while women made cornhusk masks from straw. THEY WERE WORN DURING CEREMONIES THAT WERE SUPPOSED TO CURE THE SICK AND DRIVE DISEASE FROM THE HOUSE. However, they did not seem to work against the European diseases that decimated the native populace.

A corn husk face mask from the Iroquois tribe, mainly worn by women in seasonal fertility rites

Typical Iroquois 'false face' mask used to cure diseases; there was a group of wearers of such masks known as the False Face Society

Masks were not designed to disguise the wearer. Rather, the wearer was supposed to be transformed into the spirit of the mask.

The masks would be used in a variety of 'FALSE FACE' ceremonies. To take part in one of these, a man would first have to have had a dream of a face. Then he would go and carve the face from his dream on a tree. The tree would then be felled, and the log taken home where the carving of the mask could be completed.

Carved masks were painted all red or all black, though occasionally they come half-and-half. Horse tail was used as hair. As well as curing ills, masks of the Great Defender were used to turn away tornadoes.

Other masks depicted the Doorkeepers who prevented anyone entering or leaving the longhouse during the False Face ceremony. And there were the Common Faces, lesser spirits such as the Good Hunter who founded the False Face Society. Smaller versions of carved masks were used as amulets.

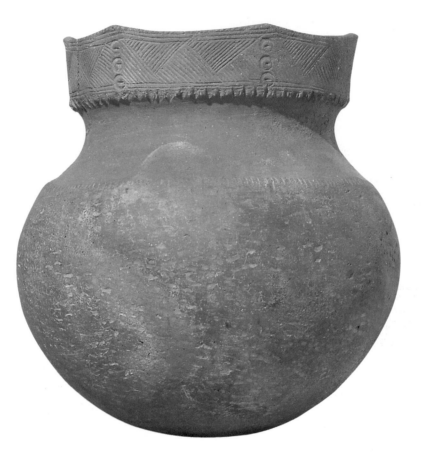

An Iroquois pottery vessel with scalloped-collar incised design, dating from the 16th Century

Carved masks were created principally by the Iroquois and the Delaware, who showed less variation, though that may be because fewer have survived. There was also another range of less religious masks. These were the so-called 'BOOGER' masks which ridicule strangers – other Indians, whites and black slaves. The Native Americans felt that such people did not know how to behave like human beings, their masks featuring twisted, grotesque expressions.

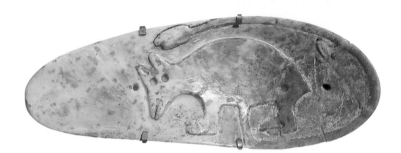

The Corn Husk Face Society was open to both men and women, but women were thought to have a closer link to corn and fertility. Masks were used in various curative and seasonal ceremonies. Women also wore Husk Faces at ceremonies where men wore their false faces.

A sandal-sole gorget (body armour) decorated in relief by the northern Kame people

Dolls of the Menomini tribe, these served to keep husband and wife faithful to each other

Before the arrival of Europeans, the wheel was unknown to Native Americans, so most POTTERY was built up out of coils of clay. However, the Eastern Indians employed a different technique. They used a small paddle to spread clay evenly around in the inside of an inverted jar, which acted as a mould. Extra coils were added later, for bowls had to be extended or closed like a jar.

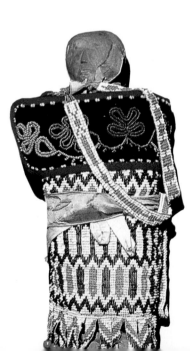
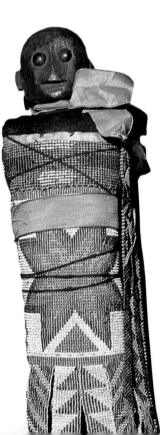

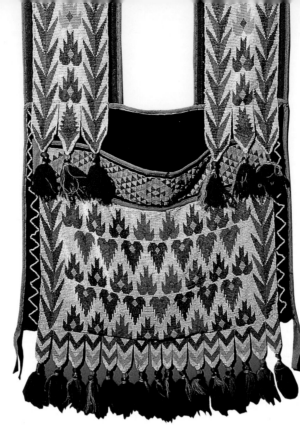

More common, though, were carved wooden bowls and utensils. Men spent much of their leisure time carving them and, when a man married, he was supposed to provide his bride with a full set of carved kitchen utensils. Sadly, little survived the small-pox epidemics which came in the wake of contact with the Europeans. Ailing Indians who were physically too weak to collect firewood burnt their wooden utensils to stay warm.

A spectacular bag woven by a Shaman of the Menomini tribe, south of Lake Superior

A moosehair embroidered screen, fashioned by the Hurons between 1840 and 1850

However, some small effigy warclubs made by the Algonquins have survived, as have Iroquois antler combs. These are decorated with tribal and family symbols, and were worn by ranking women of the clan. Traditionally, they were used in a condolence ceremony, THE END OF MOURNING BEING SIGNIFIED BY THE COMBING OF HAIR.

The Iroquois also used relief carving on brightly painted cradleboards, though their influences were largely European. Naturalistic depictions of animals and plants indicated depth by overlapping.

The Indians of the Great Lakes scratched out sacred symbols on scrolls of birchbark. They were skilled at quillwork and the decoration of tanned hide. When the European fur trade got going, they traded pelts for coloured beads, which replaced quills in decoration. The designs showed a European influence too. NATURALISM TOOK OVER FROM ABSTRACTED PATTERNS. Floral designs, particularly, could be very intricate and lifelike.

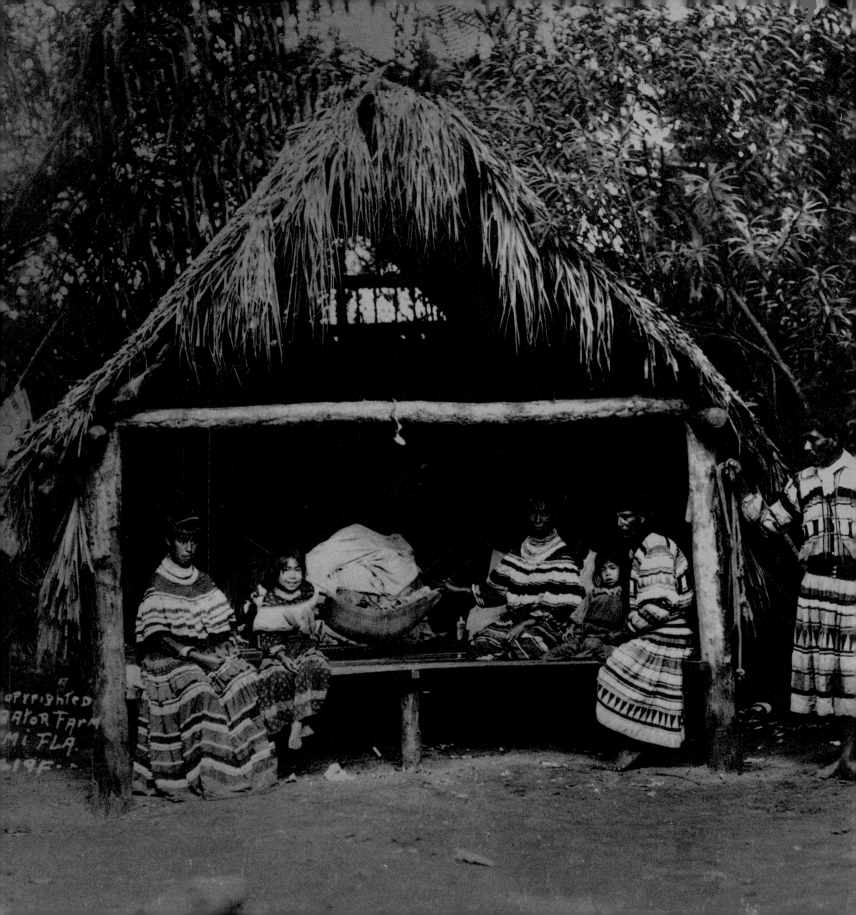

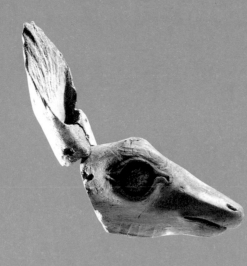

the tribes of the south east were great BUILDERS. The Creek laid out their towns around a public square. In it, there would be an open-sided building where council meetings were held in the summer, and an enclosed building for winter meetings. In one corner of the square, there would be a yard for games and sport, and there would be a hot house for winter activities. Houses would be arranged in groups around this central cluster of public buildings, with the small houses of the poorer inhabitants relegated to the fringes of the town.

Cherokee villages were built around a huge, seven-sided house. Made of earth, it was dome shaped and would hold up to 500 for ceremonies. It would be surrounded by sports fields and communal farming land. In the corners of the fields, there were small rectangular houses with bark roofs and walls plastered with clay.

A deer head effigy from Key dwellers, found at Key Marco, Florida, and dating from before the contact with Europeans, between 800-1400 AD

Florida Seminole family group in their *chickee* dwelling, with a baby in a hammock. The undated photograph was copyrighted 1921

However, the Mississippian culture of the south east had been in a long decline before Europeans arrived. When the French and Spanish started to colonise the area in earnest, the Indians abandoned their old traditions and the Choctaws, Cherokees, Chickasaws, Creeks and Seminoles quickly became known as the 'FIVE CIVILISED TRIBES'.

But adopting European ways did not save them. After Louisiana and Florida became part of the United States, these tribes were forced off their ancestral lands and resettled in the 'INDIAN TERRITORY' of Oklahoma, losing what remained of their culture on the way. Only one group, the Florida Seminole, managed to resist the move by hiding out in the Everglades. When they

re-emerged little of their art remained. What did had been changed irrevocably by the contact with Europeans.

Fortunately, the pre-colonial Indians buried artefacts with their dead in large burial mounds. These show that they had developed several distinct styles. One was curvilinear and highly stylised – though human figures, animals and astral symbols can all be clearly distinguished. This style was used in delicate carved shell jewellery.

There was also a realistic tradition. Human figures sculpted in stone and wood have been found. THE CHEROKEE CARVED HUMAN FIGURES ON THEIR PIPES AND, OCCASIONALLY, DEPICTED EXPLICIT SEXUAL ACTIVITY IN THEIR SCULPTURES. Although the Indians of South America often displayed a free-and-easy attitude to sex, this is rare among the tribes of North America. The Plains Indians occasionally depicted amorous scenes in their pictorial art, but the couple are modestly covered by a blanket.

POTTERY, PAINTING AND ENGRAVING USED GEOMETRIC FORMS and, especially, spiral patterns as decoration. The Native Americans of the south east also incorporated these designs into their bead work. Unlike other Native Americans, the Indians of the south east were not influenced by European floral patterns, in their bead work at least. They retained their traditional abstract quality and the scroll patterned sashes of the Choctaw even maintained the earlier tradition of all-white quill and shell work.

The Cherokee made masks in the Iroquois tradition, but more crudely realistic. However, some of the finest examples of mask and figurine carvings were found recently on the Florida Keys. Made by the Calusa, they are decorated in bright colours and some show a mastery of technical skill unparalleled on the eastern seaboard.

The Chitmacha and their neighbours in Louisiana were expert basketweavers. Using extremely narrow cane splints, they created complex curvilinear patterns. With the introduction of metal tools by the Europeans, the Cherokee took to splint cane basket weaving, creating patterns by using splints of different widths and colours. Overlay and false embroidery were also used to produce curly decorative elements. Interestingly, there was an enthusiastic revival of the Cherokee art of basket making in the 1930s.

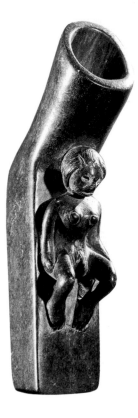

A Cherokee ceremonial stone clay pipe from the eastern woodlands of Georgia

The wooden pelican dates from the pre-colonial period, found at Key Marco in Florida

Following considerable intermarriage, the Cherokee adopted European embroidery, decorating buckskin using commercial cotton and silk threads. The Florida Seminole became adept at cotton ribbon appliqué. Originally confined to borders, by 1900 these patterns began to cover an entire garment, horizontal stripes covered in geometric patterns and meanders. And, around 1915, the Seminole adopted the Plains tradition of patchwork.

One of the most influential post-reservation woodland artists – Fred Beaver, whose Indian name is Eka La Nee (Brown Head) – is a Creek-Seminole. Born in 1911, he was influenced by Susan Peters and the Kiowas of the Oklahoma School. Beaver admits to other influences, as diverse as the pin-ups in *Esquire* magazine and Toulouse-Lautrec. However, he employs his extensive knowledge of tribal folklore, and the central theme of his paintings is Seminole life.

Modern-day Cherokee wood sculptors have also come to the fore. Encouraged by the local Indian Arts and Crafts Board, Amanda Crowe, Johnson Catolster and 'Going Back' Chiloskey collaborated in establishing a thriving group at Qualla, North Carolina. Native North American art, albeit decimated, lives on.

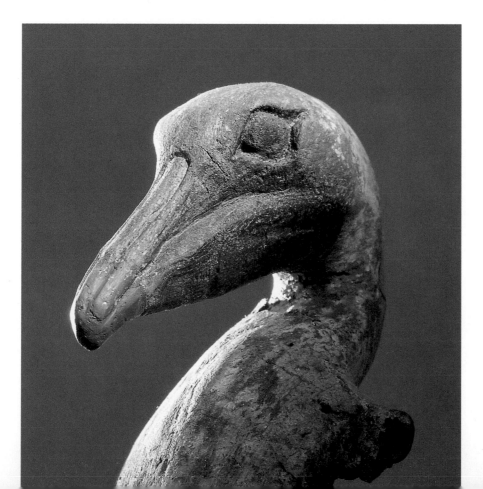

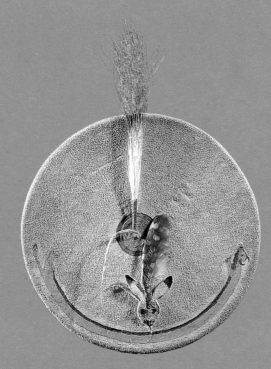

ACKNOWLEDGEMENTS **Bridgeman Art Library** / Bonhams, London 89 / British Museum 43 /Indian Cultural Centre, Albuquerque, New Mexico 79 / Museum of the American Indian, Heye Foundation, New York 56 / Private Collection, California 70, 71 **C.M. Dixon** 16 tracing, 21, 22, 26/27, 29, 30, 34, 49, 58/59, 61, 63, 66/67, 68, 75, 76, 80, 81 tracing, 81, 82/83, 84, 85, 87 bottom, 88 / Royal Scottish Museum, Edinburgh frontispiece, frontispiece tracing, 36/37 **Werner Forman Archive** 20, 94 / Arizona State Museum 24 bottom / British Columbia Provincial Museum, Victoria 38, 40, 62 / William Canning 32 / Centennial Museum, Vancouver 64 / Field Museum of Natural History, Chicago endpapers, 19, 44, 46/47, 48, 48 tracing, 53, 54/55, 69, 96, 97 / Glenbow Alberta Institute, Calgary 51 / The Greenland Museum 33 tracing, 33 / Museum für Volkerkunde, Berlin 52 / Piers Morris Collection, London 77 / Museum of Mankind, London 35, 50 / Museum of Northern Arizona, Flagstaff 24 top / Museum of the American Indian, Heye Foundation, New York 23, 25, 57, / National Museum of Man, Ottawa 42, 65 tracing, 65, 86 / Ohio State Museum 87 top / Portland Art Museum, Oregon 41 / Mr & Mrs John A. Putnam 45 / Schindler Collection, New York 31, 72/73, 74 / Sheldon Jackson Museum 28 / University of Pennsylvania Museum, Philadelphia 90/91, 93, 95 **Reed International Books Ltd.** jacket, 8, 9, 10, 11, 12, 13, 14, 15, 17, 60 **Smithsonian Institution** / National Anthropological Archives, Bureau of American Ethnology (no 2145) 16, (no 44353-A) 92

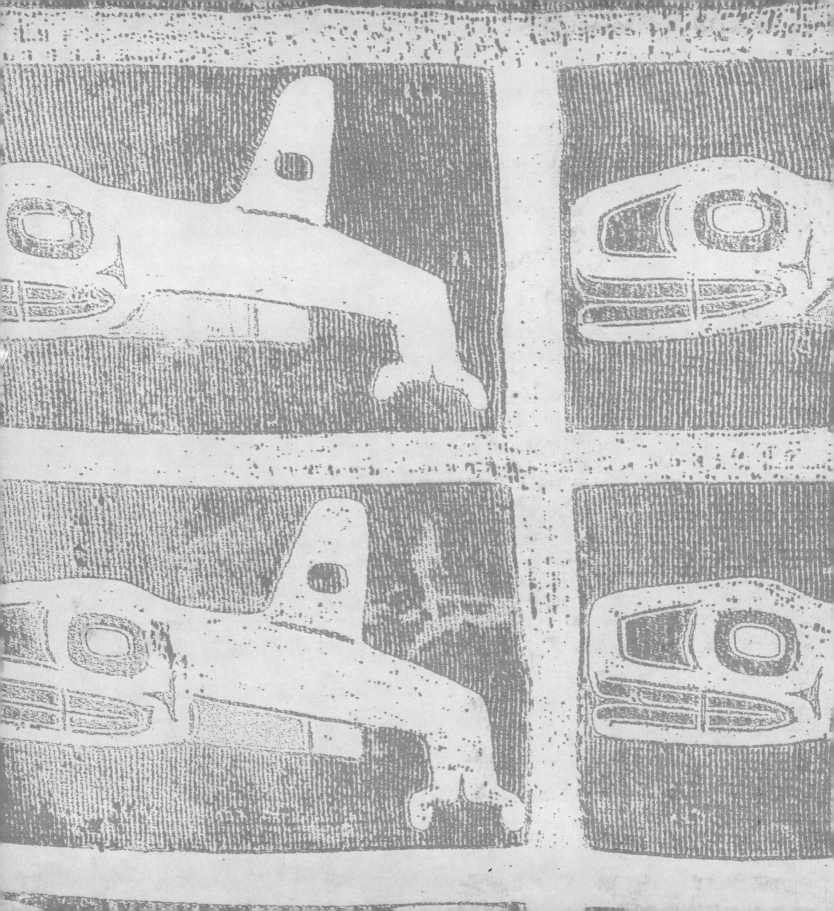